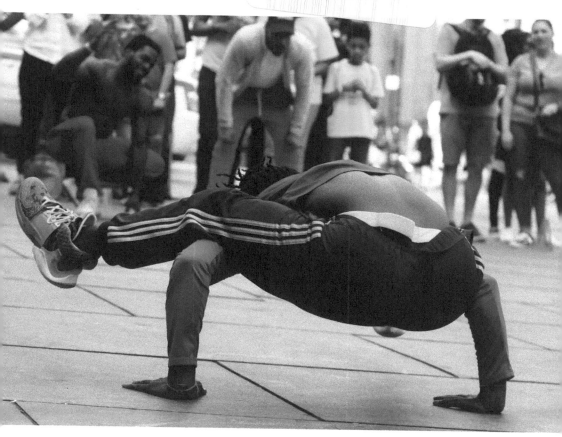

IN A WHOLE NEW WAY

UNDOING MASS INCARCERATION BY A PATH UNTRAVELED

Edited by George Carrano and Jonathan Fisher

Prospecta Press

Published by:
Prospecta Press
(203) 571-0781
www.prospectapress.com

Each large-scale credited photograph is a product of the Seeing for Ourselves ("SFO") photography program known as NeON: Photography conducted at New York City Department of Probation ("DOP") and licensed by the photographer to the nonprofit for use in this project and any extension. Other photos are credited to "SFO," "NYC-DOP," or "Supervisible." Both "SFO/NeON" photos and those uncredited were also taken by participant photographers—who implicitly granted SFO equal permission to the licenses by photographing during or as a follow-up to NeON: Photography and sharing the photos with SFO's photography instructor taken on staff by DOP.

Other photo sources collectively follow Fair Use guidelines in showing how the image of probation (and public housing) changed over the years.

For free supplementary material, visit inawholenewway.com/bonus.

Paperback ISBN: 9781632261175
eBook ISBN: 9781632261182

Cover photo: Andrew
Frontispiece photo: Elsa
Photo above: SFO/NeON

CONTENTS

PREFACE

Who do you picture when you hear the word *probation*? A tired, sullen stare. An orange jumpsuit. And the individual framed by a news article with a snarky headline. Not someone who has just obtained a second chance to get it right. Not someone who has merited a sentence of community supervision as the appropriate sanction for an offense. Rather, an offender inexplicably and luckily shown mercy.

This is a book about the redemption of three million such Americans.

Rehabilitation was baked into probation from the start, while redemption would have characterized our country from even before its founding. The *Mayflower* landed at Plymouth Rock in search of forgiveness (ironically, a year after Africans were first brought to these shores in chains, not to mention how calamitous European settlement was for those living here at the time). The Puritans who arrived afterward saw their settlement as a city upon a hill, the new Israel, building upon the redemption won in the Exodus from Egypt. The new land would be a second chance to get it right. Meanwhile, Christians have imbibed the story of Paul's redemption along with their mothers' milk.

We love redemption stories; untold numbers of Hollywood screenwriters down to today have been inspired by the 1942 film

of bar owner Rick and Vichy cop Louis finally jettisoning their above-the-fray stance in the French protectorate of Casablanca to join the most important struggle in history. Meanwhile, *Black Panther* in the modern era is said to not only feature redemption, the film offers it to viewers, as a consequence of a new concept of Blackness.

The following tale shows the world of some New Yorkers accorded an alternative to incarceration by the country's dominant—yet often still mocked and all but unknown—criminal justice sanction. Generally offered in place of a jail or prison sentence, probation is a form of community supervision. To ensure their compliance with the often-arduous conditions of their supervision, those on probation must report regularly to the probation agency and remain subject to unannounced home visits.

The story of their lives is told visually by the individuals themselves and their neighbors. None is in a position to tell it better—not the courts, not the usual nonprofits, not the bureaucracy, not the academy, and not photojournalists. This is photography "from the inside out," expressing the visual perspective of those actually living the life, and, as a result, different from almost all other collections of photographs. When a high-end Sigma camera is distributed to those usually on the other side of the lens, the difference in perspective from culturally dominant imagery is striking.

For our part, we of the nonprofit Seeing for Ourselves equipped and trained these artists in the interest of countering negative stereotypes afflicting probation clients across the country. Our text simply provides context for the photography and the participants' artistic statements—something about what brought those serving probation terms to this point in their lives. In the process, something about what brought probation to this point in American jurisprudence. And where we all go from here.

We came to this role by conducting a similar "participatory photography" effort on behalf of the city's housing project residents from 2010 to 2013 while ensconced at the housing authority. George Carrano had founded the nonprofit in 2010 with the encouragement of world-famous photojournalist Philip Jones Griffiths. The latter had seen the show of participatory photography George had mounted in New York City in 2004 on returning home from London, where he had stumbled onto an exhibit of such imagery in a church basement.

The public housing initlative led to the publication of *Project Lives: New York Public Housing Residents Photograph Their World* in 2015. The book evidently persuaded the city there were none more favorably situated to conduct a similar program for New Yorkers serving a term of probation—another marginalized population. And so, during 2018–2021, we embedded ourselves in the probation department.

We quickly noticed that, like residents of housing projects, those on probation do not deserve the scorn with which they are commonly portrayed within the media and popular culture. Contrary to common belief, they have not simply caught a lucky break on the way to lockup. Rather, they are among those found to be—after extensive investigation—both deserving of another opportunity to live a law-abiding life and capable of being safely supervised in their community instead of in jail or prison. Such an outcome helps not only them but everyone else as well. At least as practiced in NYC and certain other jurisdictions, when completed probation leads to less lawbreaking than incarceration and comes in at a far lower expense. And don't we benefit when we treat others humanely?

Still, there is a line we can't cross. Almost anyone can screw up once, but in contrast most agree that not everyone deserves a second chance: a father killing his daughter for the insurance payoff; a mother framing her daughter for her own slaying of

her husband, the girl's father; the hunter kidnapping prostitutes and releasing them for sport, to be tracked in their terror and shot down ... probation was obviously not an option in these cases. Those among us who aren't kept up at night by these true crime tales of American perpetrators, who aren't led to despair at times for our species, are made of stronger stuff than most. Fortunately, such offenders remain a rare breed. Meanwhile, many factors beyond the scope of this book help account for even the lawbreaking related here.

Where it does pose an alternative, probation has not lived up to its potential. By shining a positive light on the *terra incognita* of American justice, *In a Whole New Way* aims to build a constituency for making better use of probation—returning the practice to its rehabilitative roots from where it has gone astray. In doing so, we hope to make it easier to offer probation more widely as an alternative to locking people up.

This book does not relate the full story of probation. Our tale is impressionistic rather than definitive and shaped by our having

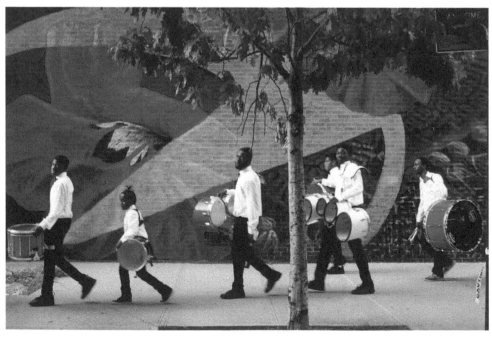

EDLYNNE

been embedded at a particular agency. And while we recommend that the probation industry follow the practices instituted by the New York City Department of Probation (DOP), these need to reflect the culture of the respective organization and community it serves, rather than copied wholesale. Further, agencies attempting reform will find themselves constrained by law as well as by the judicial or executive branch of government they inhabit. Meanwhile, DOP's Commissioner Ana Bermúdez is the first to point out that many other agencies across the country have already reformed their practices.

The aim of ending mass incarceration has supporters across the political spectrum. By reforming probation and re-establishing it as a viable option for many ordinarily bound for jail or prison, we Americans will have embarked on one of the most promising paths towards this end.

Readers may notice that individuals go unnamed in this book unless they bear a direct connection to probation and/or photography. This mirrors the practice in *Project Lives* and is intended to keep the focus on those so long marginalized in the culture.

Those with an interest in experiencing this tale in another medium are encouraged to view the eponymous half-hour documentary available online. The film was selected by over 150 festivals the world over during 2021–2022—winning over fifty awards—and was accepted for TV broadcast in 2023 by PBS. Legislators of both parties, justice officials, and the national probation industry embraced the film.

Finally, had another locale—Spokane, say—invited us in, we would have served a far different probation population than in New York. As it was, we clearly differed from the program participants by race as well as class, the two great American divides. Yet we two New Yorkers of two different generations—or three of three different generations, if including the photography teacher we placed at

DOP—saw our role as merely providing a platform for participants to take back their own narrative. In so doing, they would help millions, even if not consciously. Armed with a new artistic technique, they set off in a whole new way towards justice reform, while obtaining a marketable skill to chart a personal path forward. The large-scale photographs and artistic statements are their stories, not ours.

We look forward to the participants leveraging their stunning works in the interest of additional aims.

George Carrano and Jonathan Fisher

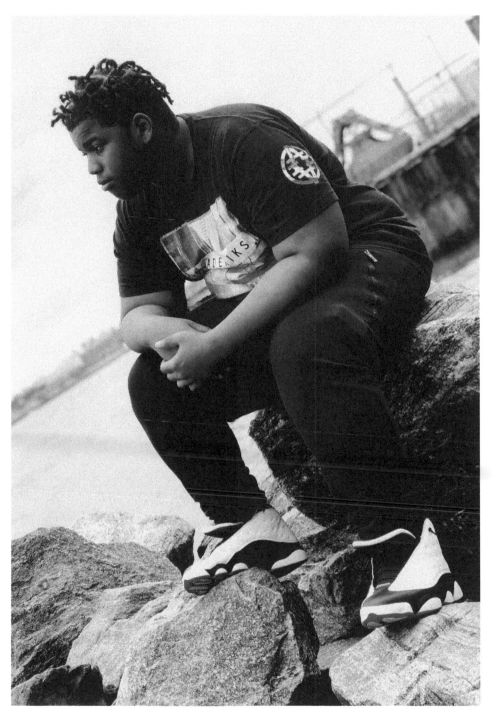

My son, Quadire, he raised me. Next came my daughter, Izena,
she made me. Last came my daughter, Isis, she tamed me.
MOSHELLE

INTRODUCTION

This is a book about second chances for New Yorkers who by definition did not take full advantage of their first—including many individuals who, it could be argued, never had much of a first to begin with.

And this is also a work about a second chance for the criminal justice sanction that provides that second chance.

When Americans give a defendant the opportunity to be supervised in their community rather than jailed or imprisoned, the latter has been accorded probation, another shot at avoiding lockup following an initial departure from the straight and narrow.

A nineteenth-century homegrown innovation, probation strongly appeals to our sense of charity (if not our sense of justice), perhaps in part because incarceration in our land remains so unforgiving. We astonish other industrialized nations with the glee we apparently take in a prisoner's suffering—in our institutions where punishment eats rehabilitation for breakfast seven days a week. However, if an individual can be spared that fate without seeming to endanger others—and better still, be shown a path to a law-abiding life—the other 333 million Americans often provide the means, even if they have no real idea of the probation process.

Yet when the late twentieth-century crime wave swelled probation's ranks, both the crime wave and ballooning numbers turned the originally rehabilitative service punitive, converting it into a staging area or stepping-stone where the unfortunate idle prior to jail or prison rather than an off-ramp from justice system involvement. The US remains in an era of mass probation and mass incarceration.

While many jurisdictions have by now returned to the sanction's original redemptive purpose, reforms elsewhere have been stymied by relentless media scorn of the penalty. This was apparently juiced by a lingering resentment that such a "get-out-of-jail-free-card" was even on offer when the crime wave originating in an individual's trauma in turn traumatized so many.

And so when hundreds of Americans enlisted in a novel effort to redeem their or their neighbors' second chance by changing probation's image, they offered a second chance to the sanction itself.

HENRY

Broad-shouldered and broad of face, sporting a thin mustache and a black porkpie, Henry lends an unmistakable presence to any gathering. He for one had a first chance and may have traveled the most winding path to redemption of anyone in the photography program.

"I had positivity in my life from the beginning," he acknowledges. "It wasn't like I grew up in an abandoned building or a place where there was no hope. It was the choices that I made." Taking responsibility for one's offenses remains a cornerstone of probation practice.

"I was about eighteen," Henry remembers. "I was hustling in the park. One night while I was at my

favorite little cousin's birthday party, my best friend Shaquille was shot and killed in the park. He was sitting on the table when he was shot in the back of the head and fell to the ground. His body was left there between the handball court and the benches.

"If I was there that night, it could've been me laying on the ground as well," he says, his voice rising to drive home the point.

"I knew from then on that it wasn't worth it. The hustle didn't mean that much to me to lose my life over it. It was just a matter of me finding a way out, finding something that was more meaningful or was going to take me out of where I was at."

But that journey would last fifteen years.

An offense less hazardous to himself and others than what he describes as hustling would land Henry on probation in 2015.

At first, he could not fathom how he would benefit from the sanction. He would just grit his teeth and get through it. But then he discovered the photography course. He would later recall his epiphany to the host of a local TV news show. "I knew from that point forward this was what I wanted to do. It was like a rush, you know?"

And Henry was off to the races. He attended every class, got his work exhibited in every gallery exhibit, even began to teach classes himself. Way beyond imparting the skill he himself had just mastered, his tone touched something in his students. "Be open to new things. You can do anything! It doesn't matter what people say or what people do to you. It's how you react to it. It's all about how you react to it that matters."

Eventually, the nonprofit running the project and the probation agency hosting it had no alternative but to appoint Henry the associate

director of the enterprise. Introduced as such and carrying himself more proudly than ever, he once sat in on a class in the photography teacher's graduate social work program at Columbia University (taught by one of probation's national reform leaders).

His days of lawbreaking had apparently ended for good when Henry successfully completed his term in 2021. By leveraging the training and his own vast network, he became a full-time photographer. Henry's imagery—along with that of other program participants—even began to undo the mocking media image of probation that had for so long thwarted reform and encouraged mass incarceration.

No easy lift even for those with the most advantageous credentials American society has to offer.

Life is beautiful. Don't hold back to show your colors. How, in every way. When you wake up in the morning, you see the sun shine. You hear the voice of the birds that becomes music to your ears and you see the colors of the plants that surround you.

JESUS

"

**IT CAUSED
ME TO BE
THE FATHER
OF MY SON
IN A VERY
DIFFERENT
WAY."**

ONE

EQUIPPING AND TRAINING THE JUSTICE WARRIORS

The nation's top political operative—a fan, like the chief of Gotham's Sex Money Murder gang, of The Art of War *and* The Prince, *and a functionary who fancied himself, with some justification, a rock star—had set a hundred researchers to find dirt on the likely opponent of his boss in the year's presidential contest.*

Reviewing their report in his spacious HQ in Washington's elegant Renaissance-revival Woodward Building in the spring of 1988, the slim Southerner may have visualized the scene two years earlier: the tall inmate with the towering Afro laboring in the cramped, grimy reading room over a form sporting the logo of the Massachusetts Correctional System, moistening the prison-issue pen with his tongue to restart the ink flow periodically. The weekend furlough the convict applied for would soon be approved by officials reporting to the state's governor—now the presumptive nominee of the opposing party.

The researchers could hardly have failed to uncover the case of a different convict, actually pardoned by the governor thirteen years earlier. But he was white, so the matter could be pushed aside.

The operative's heart may have beat faster as he reconsidered the opponent's vulnerability. "I'm gonna strip the bark off the little bastard," he would later vow to his people.

Before long, one of all these men would be denounced by a United States congresswoman for his activities as "probably the most evil man in America."

Some two hundred and thirty miles to the northeast and three decades later—yet which would not have transpired but for the earlier chain of events—twenty-five-year-old Chantelle rushes through the dilapidated East New York streets to make it in time for the preschool play, her pace slowed by her four-year-old twins running circles around her knees. She suddenly spots an elderly acquaintance leaning against a six-story walk-up and stops, struck by the play of shadows across his face in the Brooklyn dusk. She reaches inside her bag for the Sigma camera to record the moment. Another picture for her class at the probation department.

In the spring of 2018, clients of New York City's probation agency and others in the community attended an unusual class, taught by our nonprofit Seeing for Ourselves (SFO) in the confined, green-and-white-walled space of the Bedford-Stuyvesant community center—its so-called Neighborhood Opportunity Network—or NeON—locale, which delivered a variety of offerings to those the agency supervised. At one point, students scrutinized, on the Dell PC, Chantelle's photograph of her neighbor, the instructor pointing out how it reflected (or didn't) the lesson covered the previous week.

Bed-Stuy Neighborhood Opportunity Network center. Photo: SFO/NeON

The course aimed to put forward an authentic portrayal of the lives of those serving a term of probation, so as to counter scornful treatment by the media. This was photography "from the inside out," turning the traditional photo-

journalism paradigm on its head. The marginalized would define their own public narrative—even, in the photos of the probation process, their view of probation itself.

THE EVOLUTION OF PARTICIPATORY PHOTOGRAPHY

This school of photography originated among a cadre of American women providing agricultural and medical aid to Chinese living in the countryside in 1992. The volunteers found that when local farmers were equipped with cameras and trained to document their own lives, the photography elicited a new visual narrative—one unmediated by external perspectives, one that shattered stereotypes.

Using artistic means to redefine one's own public image enjoys a long pedigree. In pharaonic times, wall paintings often featured a likeness of the artist as if to shout, "Look at me! I did this!" Later, various Roman generals published literary memoirs to boost their reputation, *The Jewish War* and *The Gallic War* among them. But until 1992, only those with wealth and power could conduct such a re-casting of "The Brand Called You," to cite a widely influential *Fast Company* article from later that decade. One notable signpost on the path to photographic rebranding was Frederick Douglass's belief that photography could help correct for the misrepresentation of Black Americans in popular caricatures; later, W.E.B. Dubois noted that the identity of the photographers themselves held the key to authentic representation.

For both the high and mighty, and disadvantaged populations, how we are seen influences not only how we are treated—as everyone from Egyptian muralists to Douglass and Dubois realized, and the basis of the $154 billion American public relations/advertising industry—but even how we act. When we seem devalued by society for whatever reason, we begin to behave accordingly.

Participatory photography has evolved since its origins, becoming the frequent terrain of non-governmental organizations (or

NGOs) in partnership with government. The trend alarmed an early British devotee of the practice. Her 2015 doctoral thesis *Whose Pictures Are These? Re-framing the Promise of Participatory Photography* cited a twentieth-century French social theorist's skepticism of "governmentality" and critique of the power relationships in such arrangements. Coincidentally or not, the same theorist also inspired the concept of net-widening of state control that would come to vex the practice of probation itself.

As if to exemplify the new normal, in 2010 SFO—which, likewise coincidentally or not, had once worked closely with the UK practitioner and her group PhotoVoice—brought a participatory photography program to the New York City Housing Authority (NYCHA). The nonprofit equipped and trained hundreds of housing project residents to document their lives. The initiative had the aim of counteracting a media fixation with crime and disrepair

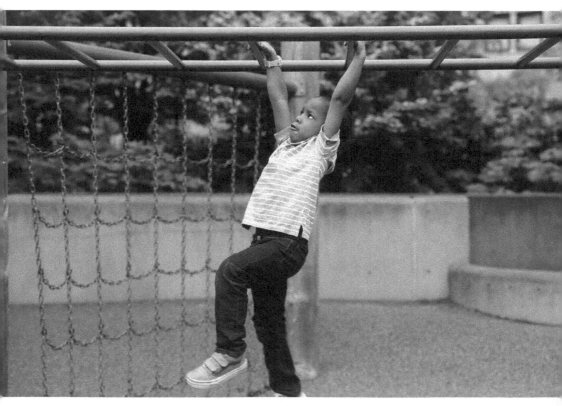

EMROSE

within these projects. A fatal case of such maladies had led to the intentional implosion of the Pruitt-Igoe development in St. Louis four decades earlier. The globally televised event haunted public housing ever since. The myopic focus of newspapers, TV, and film on shootings amid broken-down buildings kicked off by Pruitt-Igoe's destruction had discouraged further public funding, ensuring the intensification of such afflictions.

The nonprofit's initiative led to the publication five years later of a book, *Project Lives: New York Public Housing Residents Photograph Their World*, which through media reproduction of the photographs would place new, different images in front of millions of people. The globally acclaimed work won fans across the political spectrum and helped restart government support of the projects. Even in our Instagram age of infinitely available images, photographic training and the platform accorded by a widely noticed book seemed to prove the continuing validity of participatory photography.

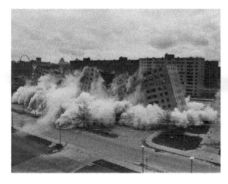 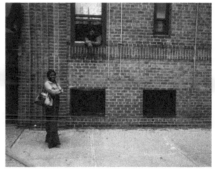

Old imagery: Pruitt-Igoe comes down, 1972. Photo: *St. Louis Post-Dispatch* *New imagery: Project Lives, 2015.* Photo: SFO

TEACHINGS

Three years after publication, we of SFO found ourselves serving a different collection of clients, hailing from the seven precincts where New York City's Department of Probation (DOP) operates

in a decentralized fashion. These are some of the most disadvantaged communities in the city. As Bronx participant Emily observed, "Our neighborhood doesn't come from seeing doctors and lawyers. I come from drug dealers, gangbangers, robbers." More than a few residents had found that these environments offer limited options to keep a friend or loved one out of harm's way while remaining on the right side of the law.

The probation agency had sensed that the nonprofit's practice was tailor-made to counter the relentlessly scornful treatment of the sanction by the media (especially since the election campaign of 1988), portrayals that had helped kneecap efforts by some of the department's clients to leave their pasts behind. Indeed, the derision heaped on three million such Americans across the country by the popular culture epitomized the obstacles facing those who—having used up their first chance often because of a single mistake—are currently grasping their second chance by serving a term of community supervision.

And so the course, "NeON: Photography," had taken its place as one of the programs within the seven NeON community centers that also include artistic, athletic, educational, and health and wellness programs. This variety of offerings aimed at enriching lives is intended to lessen the appeal of unlawful activities.

Deserving of second chances in the nation's capital of second chances, those students serving a probation sentence had wound up supervised in their communities, generally in place of incarceration. (The justice system offers parole to the incarcerated—with which probation is often confused—as a form of early release.) The photography class attendees included hundreds of men, most of whom hit DOP's sweet spot for intense supervision and rehabilitation by falling between the ages sixteen and twenty-four (sandwiched between a smattering of younger teens and males as old as fifty-one), along with far fewer women, aged sixteen to thirty-one.

Meanwhile, a glaring fact about New Yorkers on probation remains the predominantly Black and Hispanic nature of the population. (Nationally, white Americans constitute the majority.)

The sentences of those enrolled in the program ranged from ten months to five years, stemming from offenses from drug possession to crimes of violence. The NeON: Photography course (along with other agency programs) also attracted general members of the community, youths as young as age fourteen and seniors as old as eighty, a practice DOP deemed critical to lessening the stigma associated with probation. These neighbors would prove steadfast allies in the current effort.

One such was a probation client's own father. Long estranged from Michael, Carl of East New York reported that the program "caused me to be the father of my son in a very different way. It changed the relationship from competition to appreciation of art."

From March 2018 to the 2020 pandemic, the Seeing for Ourselves photography teacher—now taken on staff by the probation agency as both the instructor and linchpin of the SFO/DOP partnership—handed her pupils an assortment of cameras for use in the twelve-week photography course, while encouraging use of their own cell phones as the occasion warranted. Some of the most exceptional program graduates would come to share teaching chores.

Recruitment of students proved a hurdle at first, only one brave soul showing up for some classes. SFO was, after all, an unknown quantity. A natural skepticism about motives and staying power had to be overcome.

Each week a different photographic technique—including camera language, use of color, and attention to light—was discussed and illustrated by works of the masters of the art. Chantelle and her classmates dutifully tried to put the technique they had seen in the work of these artists into practice on their missions into the

community the following days. The syllabus paid careful atten-
tion to the ways racial bias has been hard-wired into photography,
beginning with the film emulsion calibrated to capture skin tones
(foreshadowing the way artificial-intelligence-driven facial recog-
nition systems seem to recognize Black individuals less accurately
than white men, leading to false arrests). Meanwhile, the instruc-
tor arranged the chairs in a circle in keeping with restorative jus-
tice practices, where those perpetrating the offense are brought
face-to-face with their victims to offer contrition—a much more
promising route to rehabilitation than incarceration in certain cas-
es. This would influence course learnings, as we'll see. Meanwhile,
she followed the general NeON practice of not asking her students
to identify themselves as someone on probation or a neighbor (a
rule to which this book itself adheres).

And so as word got out the course gradually gained popularity.
Momentum was not a given, however. A class forsook the sylla-
bus one warm spring evening in 2018 to somehow deal with the
anguish of one young student, a close friend having just joined
the list of homicide victims. (Participants often brought more
than their recent photos to class discussion—news of births as
well as deaths.) That fall, the shocking re-arrest of one of the
most promising photographers in the course led the instructor
to cancel a class as she rushed off to Riker's Island to convey word
about his accomplishments to his lawyer.

And after classes migrated online when COVID-19 brought the city
to its knees in 2020, one remote session would leave the lesson be-
hind to mourn another participant's loss—as her husband, father,
and brother had all succumbed to the virus in a span of ten days.
But the shutdown did have one silver lining. As facilities the world
over in locations well served by broadband would discover, hold-
ing classes virtually made it possible for many more to participate,
regardless of location. Then when the city began to re-emerge
from COVID's shadows, lives adapted to new circumstances.

Let's sit in on a class in the fall of 2018, as an eighty-year-old resident of the community joins the Bed-Stuy sessions, having spotted media coverage of an exhibit of works to date. The entire class sits transfixed, listening in awe as he imparts context to their photos by describing the radically different Bed-Stuy he grew up in. He advises them to never stop growing and evolving—as he's doing now by learning a new skill. The sessions aim to meet every student at their own level, whether beginner or professional.

"I took this photo in an area that nobody really frequents," announces one youth.

The group studies the shot to see if they can guess the location.

One student observes, "It's like little things that people walk right past and never even think about." A photo that may only have been captured by a genuine insider.

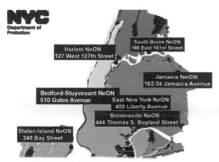

Location of Photography Workshops 2018–20.

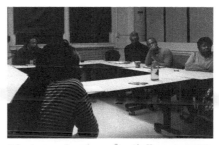

Photography class, South Bronx, 2019.
Photo: NYCDOP

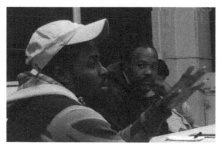

Devonte makes a point, 2019.
Photo: NYCDOP

Comparing notes after an advanced class led by program graduates.
Photo: SFO

Fast forward to January of 2019, when eight photographers on probation or otherwise residents of the South Bronx review each other's work on the classroom monitor. There's William, medium height, muscular, the class joker, riffing on every utterance. "I'm not good enough to become a professional, but I'm getting something out of this all the same. Maybe I'll at least take wedding pictures." A beat. "For no pay." Before the month was out, William will land his first paid gig as a photographer.

There's Devonte, shorter and wiry, who before class had taken his turn rapping to a mostly indifferent audience of clients sprawled in the colorful lobby of this NeON center, all awaiting appointments with their probation officers (POs). A music program representative handles the rapper's backup chores, pre-recorded beats resounding from speakers behind the performer. Like many other photography students, Devonte participates in music and the other arts.

This kind of performance in this kind of place seems totally authentic, far removed from the tickets to stardom employed by the now-famous. But to the few seniors listening, twenty-something Devonte seems a bit young to be rapping about his prostate.

Now in class, a room off the lobby, he talks about the striking image at the front of the room, differing intensities of light playing on three faces. His words strike home. A poet, Devonte had also enrolled in the Free Verse program, another NeON offering. He hadn't considered photography an art, but he's come to see it as another vehicle for telling stories.

GUILTY AS CHARGED

I am guilty

for the wrong

I've done, my

life has

become my wife.

I'm not in a great

mood. I thought

my loyalty

wouldn't make me

lonely. But

I made it happen, no

accident of

fate. No drug

or drink.

I did this.

That's why

I feel guilty.

Next to him sits girlfriend Emily, equally young, and a future NeON Photography trainer in the making. She's still mulling over what she learned last class—that the aim is not a beautiful photo, but an image expressing what is important to you. Emily, too, is a poet.

DESTROY AND REBUILD

Angry like an earthquake.

Love leaks like blood.

Murder case never solved.

The heartbreak crime of never letting go.

Time ticks while I try to heal on.

On her left a much older student, slim and balding, would like to say something about himself, but those before him stole his

thunder. He had served a probation term decades ago. "I hung out with the wrong crowd."

Patrice, in her late twenties and both an art teacher herself at a local elementary school and a practicing artist, looks to take her abilities up a notch. In 2020, she will have her work selected to fill the letters of the Black Lives Matter mural painted in front of the Criminal Court building on Centre Street in Lower Manhattan.

With the session breaking up, the students excitedly recall the recent Carnegie Hall event for DOP clients, where a renowned actor previewed his latest film and hosted a Q&A with the audience. What got their attention the most? The fancy hors d'oeuvres laid out—only a subway ride away from some of the city's food deserts where so many participants live.

Come 2021, courses will become fully subscribed almost immediately upon their announcement. By November, over two hundred will occupy the waiting list.

MICHAEL
The Son
East New York

I grew up in Brooklyn, East New York. My home life was pretty good.

When I wound up on probation, I thought "Oh, my God, I got to do everything I can to finish."

When you start, you basically snow your probation officer.

"What are you going to do for your one-year plan?"

"I plan on going to school."

But then she runs with it, so the next week it's all laid out.

"So, school. What are you going to do right now?"

I always had an interest in photography. Now, with this course, I can be somewhere in Park Slope kicking it,

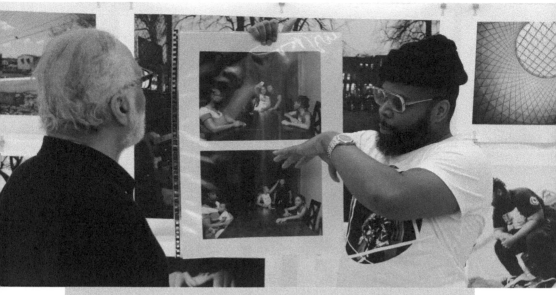

because nobody can make me look stupid. People could go, "What kind of camera you got, a Kodak Brownie?"

"No, I got a Sigma, with a telephoto zoom lens."

Carrie Mae Weems—her "Kitchen Table" was my inspiration in the course. But I wanted to be more modern. Jay-Z and Beyoncé about three months later rented out a museum in Paris that holds the Mona Lisa and shot a music video; the person who actually did the treatments to it was inspired by the same photograph! It was like a really small thing, but so powerful how that little segue was. And they

captured the artistic value of it. It was a tribute to her in a different way.

I got to shoot the Commiss-ioner herself, and the big arts wrap-up at Carnegie Hall.

I wake up in the morning and think about pictures for this book and the gallery exhibit. I'm going to get my apertures right and perfect the process. Then I can take it anywhere.

And it's a different flow now! Hey, I see the probation department really working for me! I see them more as the server rather than the administrator.

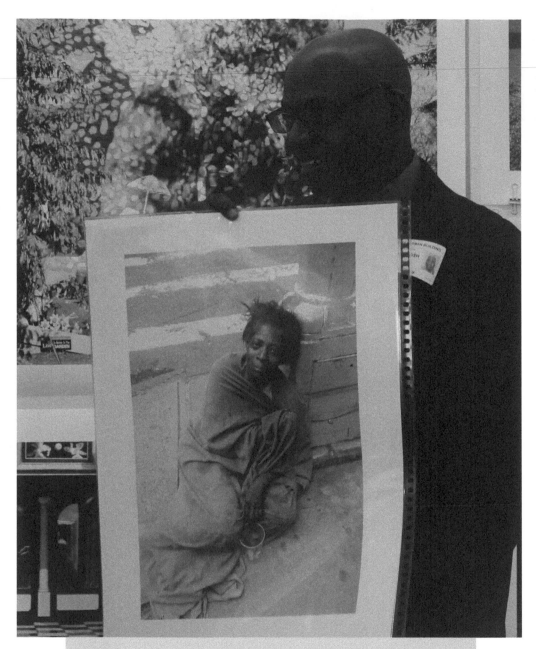

CARL

The Father
East New York

My son and I long had a complicated relationship.

Always fighting.

But with this photography program, that all changed.

Why? Because we never argue about pictures. We took all that energy from arguing and began to spend it looking at different things. That brought us together.

We'd ask each other, "What was the objective of this picture?"

It caused me to be the father of my son in a very different way. It changed the relationship from competition to appreciation of art. Michael is responsible now, to his son and the photography program.

I've been responsible, but I've also been a fuckup, too, you know what I'm saying? And I love opening the door that was closed long ago when I started to go into the capitalist world. I want to be a photojournalist, taking subjective photographs to advocate for people that are marginalized. I want to help people the way the photography network helped me.

EMILY
A New Perspective
South Bronx
Transitioned to Teaching

There were about, like, five or seven people in our class. Their ages ranged from eighteen to like sixty years old. So it was kinda cool!

I used to always see a little girl's sneakers hanging from the phone wire and I used to always say, what is that?

I remember wondering if it was someone dying or somebody new or somebody that was from the community. It just stood out to me, so I took a picture. I tied the sneakers and put them on the side of the fire escape. People come to a conclusion where you'll know what it is to walk in other people's shoes sometimes. And sometimes you don't know what they go through.

There's a light side and a dark side to everything. So just always keep a bright life for yourself, no matter what.

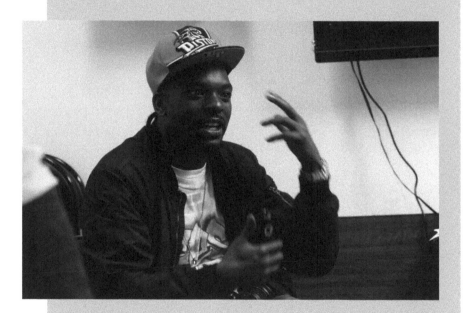

CHRISTOPHER

New Beginnings
Bedford-Stuyvesant

Transitioned to Teaching

I had heard of galleries and saw them on TV. But this is actually a gallery that I was a part of. People came to see my work, and all of the other people's work, too. It made me feel good, made me feel like I was actually a part of something different.

Cranes are new beginnings for me, so that's why I like

taking pictures of cranes. Every time you look through that lens, that's always your shot. And whatever that shot is, it could be a new beginning of anything. I'm not gonna stop! I mean, it's a wonderful thing, I can get up, take my camera with me, and just go!

"I WANT TO SHOW MY FAMILY THAT I'M TRYING TO MAKE A LIVING."

TWO
MISSION

The photography initiative aimed to achieve a panoply of ends, beginning with imparting to participants a marketable skill and career direction (not only in photography but in business in general, especially with visual storytelling a competency in increasing demand in the workplace nationwide). Of almost six million Americans subject to correctional supervision—a planet-leading total—only about half had been employed full-time when they entered the criminal justice system. DOP views a job as a way to heighten the odds that the current probation term forms the individual's only contact with the system going forward. A skill like photography remains one path to above-minimum-wage employment for those with few formal qualifications. As Dylan put it, "I want to show my family that I'm trying to make a living." With such a goal in mind, the "justice-involved" among the participants in the initiative—to use the terminology favored by the agency—would benefit from an additional incentive to complete their terms successfully, as seven out of ten DOP clients currently succeed in doing.

At the same time, it was hoped that allowing those on probation through their efforts to have an impact on so many Americans in

the future would also encourage successful completion of their terms. During the 1990s, some of the toughest juveniles in Los Angeles's probation system executed a 180-degree change in attitude when accorded the opportunity to help others—for perhaps the first time in their lives.

The program also aimed to shine a positive light on the largest slice of the correctional supervision pie (Figure 1, below), serving a population between Los Angeles and Chicago among the most populous American cities. Through the initiative, the public should obtain a better sense of the entirety of the criminal justice system that both protects and potentially threatens them.

Figure 1: American Correctional Population 2022

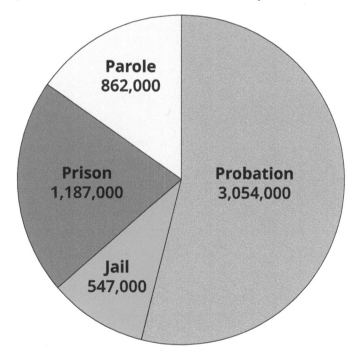

Total=5,650,000
Source: Prison Policy Initiative and Bureau of Justice Statistics

SYNCHRONICITY

Photos: Supervisible/ www.offendersupervision.eu/supervisible/

Participatory photography has made something of a mark in the criminal justice system to date—yielding new imagery of the incarcerated—while a parallel effort on behalf of those under community supervision, similar to SFO's, by sheer coincidence was underway in Europe beginning in 2014. Or perhaps this developed not coincidentally, as the idea may be in the air.

There, as well as on our own shores, probation seems little understood by the public— scarce and disrespectful news coverage a prime suspect there as well. But European experiments have shown that even positive treatment elicits only a skeptical reaction from most.

There as here, cultural depictions remain few and far between. The practice— in contrast with incarceration—is almost never treated by film, TV, theater, or music, or in books. A recent study has revealed twice as much negative coverage of probation in the English press as positive. And so, some experts view so-called "counter-visual criminology" as possibly the best way to shift the public's lukewarm attitude, with new imagery

revealing the huge distance between probation and, say, summer camp (as many skeptics view the sanction). It is felt that participatory arts have the edge in effectively supplying the new visuals required.

In the current effort, participatory photography practitioners have equipped Scots and Germans on probation with cameras, trained them briefly in their use, and asked them to document their experience under community supervision. The ensuing photographs fall into five categories: positive development or change; lost, wasted, or suspended time; constraint; waste; and signs or words—all but the first revealing the physical and psychological costs of probation.

The results have come as a wake-up call to those running the project. At the receiving end, probation goes far beyond the supervisory meetings that many officials had supposed

represent its central aspect. Those on probation experience it as far more diffuse and pervasive, extending in time and across the life of the individual. Although clients appreciate its benefits—confirming recent research in England and Wales finding that probation boosts their sense of agency, steps up their motivation to change, and enhances their problem-solving skills—they wind up emotionally and physically drained, "continually judged and constrained over time in the presence of a suspended threat."

Hundreds of photographs have been exhibited to the public thus far—the effort aiming to eventually reach all countries within the European Community, and in doing so providing evocative points of comparison. But after beginning to expand to Ireland, Malta, and Denmark, the initiative appears to have lost momentum due to Brexit.

Further, by promoting a truer picture of those serving probation than that disseminated by the media, the effort could not only achieve DOP's original goal of improving the prospects of the participants and all others caught in this arm of the system, but—by encouraging a return to the sanction's rehabilitative roots where still punitive—perform the paradoxical role of normalizing probation as an alternative to incarceration while still helping to reserve its use for only those requiring supervision.

Finally, the enterprise could show what's possible when adequate funding, shortened terms, and a rehabilitative outlook allow probation officers to properly supervise those in need of the personal touch. Low-risk individuals are allowed to check in with supervision by using self-service kiosks staged around the jurisdiction, obviating in-person interviews; probation graduates with unexcelled cred are brought on to coach those currently serving a term; community service includes a restorative justice component; clients are tasked with partial responsibility for their own rehabilitation (a practice that could be termed "participatory probation"); the agency itself is decentralized in warm, welcoming centers in the service of procedural justice and providing a single locale for wraparound services; and extensive arts and other programming chosen by the community stakeholders provides a creative or athletic outlet. Altogether, this makes up DOP's not-so-secret sauce that has made the agency the industry pacesetter in terms of successful rehabilitation.

And yet, the picture-taking was not nearly as calculated as all this may make it seem. As the SFO/DOP instructor explained and as her students immediately grasped, simply taking photographs of what mattered to them could itself accomplish the various goals.

"

SOME SEE US AS HAVING A STIGMA AND HARASS US."

THREE
COPING WITH LAW ENFORCEMENT

Venturing out into the wider city, the horizons of the photographers began to expand. Between spaces understandably perceived as white, and precincts under the sway of gangs, many residents of the seven disadvantaged neighborhoods of DOP's operation find themselves forced into small worlds, seeking solidarity where they can.

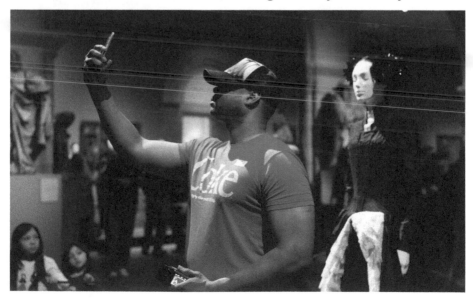

Participants explore the Metropolitan Museum of Art.
"I've lived in New York all my life. I can't believe a place like this exists in the city!"
Photo: SFO/NeON

Similarly, like so many other African-Americans, the Black participants seem caught between relentless policing of relatively minor offenses on the one hand and under-policing of violent felonies on the other. (Some argue that under-policing is to blame for allowing gangs to hold sway in the first place.)

COLLATERAL DAMAGE

By the fall of 2018, some fifty cameras had been loaned out to participants, all of which were returned well-cared-for and intact. Then one was turned in by a lanky youth (whom we'll call Oliver) with the crack in the lens glaringly apparent. He came running up, asking the program graduate who was teaching the course, "Can you look at the camera, Andre? They didn't break the camera, did they? The camera is okay, right?" The day before, a police officer had slammed Oliver against a wall during an arrest for trespassing in an open McDonald's. NYPD held the photographer overnight before releasing him that morning.

As a tiny nonprofit operating on a shoestring, we always suffered a touch of anxiety when sharing equipment with anyone, from a wealthy fellow-photographer to one of our own marginalized clients. We hadn't expected law enforcement itself to present the greatest danger.

The roots of this situation extend beyond the scope of this book, but overly aggressive policing of people of color and whites alike seems to many experts at least in part a not-unnatural response to the prevalence of firearms throughout the country—including in the seven neighborhoods of DOP practice, a plethora the participants acknowledge.

Something does seem amiss when we in effect ask our guardians to put their lives on the line simply breaking up a domestic quarrel,

whether in Harlem or a Nebraska farming community—an unintended consequence of arming ourselves to the teeth. And so, over-the-top policing may have reached its nadir not in widely notorious cases but in the little-known killing of a suspect by a Phoenix police officer who in 2018 mistook the handcuffs he and his fellow officers had just placed on the man for a danger to his own life.

Still, in spite of the saturation of the country in guns, only a handful of police officers lose their lives during the course of duty in a given year. Our continued dispensation of law enforcement to employ deadly force whenever they might reasonably detect a threat seems unreasonable itself—and even an open invitation to kill.

Only the cynical (and foolhardy) might advise police officers that taking the first bullet is the price of doughnuts, but many others—including a West Point army strategist—see that something has gone wrong when police are counseled, as were members of one of the nation's largest departments in 2017 by their commissioner, that "Not one of us signed up to never return to our family or loved ones." As the military planner points out, ignoring the moral principle of risk acceptance that the US military prides itself on and placing personal consequences above professional responsibilities may be just what leads to so many tragic shootings of Americans by their own protectors. This analysis itself appeared on the blog of a retired police chief, who had walked the talk by turning his officers into community custodians during his two decades at the helm of the Madison, Wisconsin, force. The widely noted reluctance of on-site police to engage the Uvalde, Texas, school shooter in the spring of 2022 may only have encouraged more Americans to arm themselves to protect their children.

Surprisingly, few program participants raised law enforcement concerns during the classes—the dog that didn't bark. Overly aggressive policing may have receded as a local issue with the

ending of stop-and-frisk—which had taken aggression to new heights—and the passage of time since 2014's infamous fatal choking of a cigarette salesman on the streets of Staten Island. On the other hand, there would be those in New York who blamed the worrisome spike in murder rates during the pandemic on an NYPD slowdown in response to 2020's national uprising. (More convincing explanations lay in the stress and job loss associated with COVID-19 and the justice system's diminished standing in the eyes of many.)

If Todiyah observed, "The police are kind of helpful to the community, but some see us as having a stigma and harass us," most of the photographers may have simply accepted poor policing as a fact of life in their communities. Yet another burden for them to bear.

But changes were afoot. The election of a former police captain as mayor in 2021, after Seeing for Ourselves wound down its programming, signaled a new approach in store to keeping communities safe.

OFFENSES

As one commenter on a 2018 article in The New York Times *noted about lawbreakers in general, "Having worked with this population since 2009, I can say with a fair degree of confidence that most people don't wake up in the morning with a plan to commit a crime. There is always a story behind the story. Whether it is drug or alcohol addiction, mental illness, hanging out with the wrong crowd, or being in the wrong place at the wrong time, most people doing this are not career criminals. Most will age out. Giving someone a second chance benefits all of us, not just the individual."*

THE IMMIGRANT'S TALE

I'm thirty-eight years old. I was born in Jamaica and have been living in America for about ten years now. I became a permanent resident in 2011.

I'm married with two kids. In 2011, I went to Jamaica for the first time after receiving my green card. When I came back in February of 2012, there was a new tenant in the basement of the apartment house.

My brother's birthday was May twentieth of 2012, and so on the seventeenth we were busy planning his party. I had just come into the building from the wireless shop. I had brought some Popeye's chicken in to give to my wife.

I don't know where these two guys came from. One put a gun to my head.

"Yo, we're going into the apartment."

"Like for what?"

"You know."

They shoved me upstairs in front of my brother. "Where's the weed?"

"Yo, weed in this apartment?" I asked.

"No? We'll shoot you right now."

All I remember was getting into the ambulance.

When I reached the hospital, I didn't stir for three days. Like Jesus.

I woke up with an ileostomy and a colostomy. Eighty-six staples. Tubes running everywhere. I was aware I had been shot, but what was all this?

I wasn't able to contain a thing. Whatever I ate would just run right out. So they had to keep me in the hospital.

After six months, they took off the bag and sent me home. But they had blocked me too tightly, now nothing could get through. I had almost exploded, which would have made me septic.

So back to the hospital for emergency surgery, opening up my stomach that they had just closed. I woke up in the ER. My brother was crying. My wife was crying.

"What did you do to him?"

It turned out they had cut my urethra during the surgery. And they couldn't fix it, so they discharged me. And when I got home, I felt like I was dying. Couldn't lift a spoon. My brother took me to a different hospital. They couldn't believe I had been operated on in America.

They asked me, "Which country are you from?"

So another round of surgery, this with only a sixty percent chance of waking up afterwards. But it went off perfectly. And then I started the process of rehab. I needed new stents every month until I healed.

I wasn't supposed to be able to make babies after all the damage. But then my daughter came, a miracle.

And meanwhile I was brought to court in handcuffs. It turned out that the police got into the new tenant's apartment and found the marijuana the guys had come for, a hundred or more pounds. They also discovered a gun. The occupant had parked his stuff and left straight for Jamaica. The police know him—he's already on probation.

Yet who got charged, for attempted possession of the assault weapon (whatever that means), along with possession of the drugs? My wife, my brother, my wife's mother, and me. The police did find my brother with marijuana. But less than two ounces. And that somehow tied us to the dealer?

We were offered a plea, and our lawyer advised us to take it. Three years' probation for my brother, five for me. I took the deal knowing I'm not a problem guy. I wasn't going to get into trouble. And then my family could move forward with their lives rather than being stuck in this struggle.

And so the court took the plea deal, and I began probation.

My mother-in-law sued the state and got some money afterwards. My wife lost her job because of the arrest, but later got a better one with the federal government and wound up running HR for the same people who tried to deport me because the arrest violated my immigration conditions. I wound up in a Bergen County detention center for eight months. There was all kinds of pressure. Financial. Physical. Mental. Emotional. Spiritual. But I didn't break.

I've been through so much that I've learned how to appreciate the smallest things, like using my butt to poop. I had to use a bag for two years.

Now I've served almost my full five-year probation term. But job offers disappear during the background checks.

A MOTHER'S TEMPER

My 11-year-old son and I had an issue while I was pregnant with my third child. A teenage adolescent thing. He punched me in the face. I went ballistic.

They took me to jail and my kids away.

I would have done anything to get my children back. I enrolled in a million programs by the time I saw the judge. "That's good, because I was going to ask you to do one!"

Parenting Journey in particular was amazing. It takes you back into your childhood to discover the source of your parenting issues.

But Child Protective Services, they get into your business. I don't drink much, but I like a little Beringer's after a hard day's work. It's been an issue for them.

HOW IT HAPPENED

I had my first experience with NYPD. I had a gun. It was a regular search and seizure, and I ran. I shot twice at the police officers. So I was in the wrong place at the wrong time. I had a lot going on. That was, like, the first case I ever caught. I was about fifteen, sixteen years old. That was a little bit before the Bloods and Crips era. I was affiliated with a three-letter gang.

This time I got on probation because I still had the gun in the house. It was unloaded. I was in the house arguing with a lady friend of mine. The cops came and they said, "Yeah, you have a gun in there?"

If you're raised in an environment where you really need a gun— the streets heavy—you're going to keep it. I guess I felt real vulnerable. But that's no excuse; I had it in the house.

SOLITARY AND AFTER

We all have to account for our mistakes. But taking us away from society, from our families, from our kids for so long seems disproportionate. If you're locked away for 10-15 years, then when you get out you find things have changed so much. Life doesn't wait for nobody. When you're incarcerated, you not only lose your life, you lose the life of your family.

My original sentence was for burglary, grand theft, and aggravated fleeing. It's what you get for breaking into houses and stealing cars—or just taking their rims. I got four years in juvenile.

But then I unfortunately assaulted an officer. And so I got placed in solitary in an adult facility. I didn't get out of solitary until I was released from prison. That screwed me up completely. You

can't imagine what it's like. It's been proven that anything over two or three months in solitary affects the human mind. Well, it destroys your motor skills as well.

I was nineteen when I went in and twenty-four when I got out. I was so messed up that after only three months and fourteen days on the street, I was back in prison, this time for nine years. In just that little time in-between, I met a girl and she wound up getting pregnant, so my daughter grew up with me behind bars.

And because I had been in solitary when I was released the first time, I got put into solitary as soon as I arrived the second time. And wound up staying in solitary for the whole time. When I got out, I was lost. The world didn't seem the same. I moved from Florida to Connecticut where my sister lived because I wanted a fresh start.

I contacted the mother of my daughter, and we tried to reconcile. But she herself had a lot of problems, a lot of anger—and she took it out on me. Eventually I snapped. I wound up on probation for three years, with an order of protection keeping me away from both her and my daughter.

I'm living in a shelter. I don't have a dollar to my name. I'm hungry. I've lost three jobs because I can't take people who abuse their power. I've lost my ability to suck it up. And I forget stuff, like appointments with my probation officer. Luckily, she understands my situation. She knows that I'm staying out of trouble. I don't want to go back. On probation you carry your prison with you, but that I don't mind.

I would really like to sit down with a psychiatrist, someone who can break everything down and get answers out of me, because I'm damaged in my mind.

Photography helps. But it's tough to do it here in the city. It would be easier in Maine. You take a photo of someone in New York, they come after you!

"DO YOU REMEMBER THOSE PAPERS YOU SIGNED IN COURT?"

FOUR
THE STIGMA

The original impetus for this participatory photography project was the demeaning, at times mocking, image in the media of people on probation. By discouraging reform efforts, the scornful portrayals have undermined popular respect for probation as an effective alternative to mass incarceration.

The tabloids' fixation on those few who commit newsworthy offenses (such as lawnmowing under the influence or bringing a wild raccoon named Rocky—what else—into a bar), celebrities taking their turn at community service (Lindsay Lohan caused such a sensation that DOP no longer has celebs perform it in public, while Naomi Campbell treated her DOP gig as a fashion show), and others who fail their probation in some spectacular fashion (like the Massachusetts official finally jailed after amassing two hundred violations) leaves the majority of those on probation unknown to Americans in spite of their vast numbers. While twice as many struggle with probation as languish in jail or prison, the former, when considered at all, tend to be dismissed as having caught a lucky, undeserved break—and seemingly scorned for being bad but not bad enough to be interesting.

The practice of probation itself handicaps public comprehension because it entails no architectural or physical presence like prison. As the insightful book *Pervasive Punishment* notes, most would find it difficult to picture the process.

Both cause and effect of its low profile, probation winds up almost never treated by books, music, theater, television, film, or gaming. Jails and prisons have monopolized justice sanction cultural references, from *Soul on Ice* to *Soledad Brother*, from *Folsom Prison Blues* to *Midnight Special*, from *Oz* to *Orange is the New Black*, from *Cool Hand Luke* to *The Shawshank Redemption*.

And because most of us can't imagine the process, we might assume the absence of probation altogether, undermining public faith in probation itself.

One of the rare films that did feature probation, the 1996 thriller *City Hall* featured DOP itself. In the movie, the killing of a six-year-old bystander triggers an investigation into why the shooter—a Mafia dope pusher—had been given probation for his offenses. The pre-sentence investigation (or PSI) that recommended it, signed by a supervisor, turns out to have pre-empted an earlier version conducted by a rank-and-file PO suggesting ten-to-twenty in Attica. It is then revealed that someone high up in city government got to the judge to ensure his acceptance of the new proposal.

This was not the kind of portrayal likely to instill appreciation of the probation function generally—or of DOP in particular.

At the other end of the spectrum lies the heartwarming 2013 Canadian film *If I Had Wings*. A friendly suburban PO enlists a youth on probation—who attends the same high school as his deaf son—to coach the latter how to win races, with the judge strangely approving such a novel if nepotic arrangement. If the client fails at the task, placement in a juvenile residence will await.

It is no accident that the young man shouldering the movie excels at racing—that traditional trope of freedom. It's also no accident that the rival in the race turns out to be a wealthy blond teen, the client himself mired in poverty. No accident that resisting the influence of wicked peers presents a special challenge. And no accident that problematic parenting influences everything.

Each of these also peppered the plot of *The Loneliness of the Long-Distance Runner*, a 1962 British classic focusing on a young thief who declined a detective's offer of probation if he confessed, but then ultimately nabbed with the goods and winding up in juvenile placement. Itself the heir of the seminal French New Wave film *The 400 Blows* that traced an adolescent's path to placement, the film seems to have strongly influenced the 2013 Canadian effort.

It transpires (spoiler alert) that the young racer in the later film more than rises to the occasion, finding—as had the 1990s Los Angeles juveniles—that being asked for perhaps the first time to help someone else catalyzes a turnaround. Both the probation officer and juvenile racer are treated positively. With a wider audience, this film might have strengthened the indifferent probation brand.

More recently, the plot of *Little Woods* (2018) hinged on what has become a cliché in this genre: the seemingly irresistible temptation to violate the stipulations with only days left in one's term. The probation officer is kindly but not astute enough to figure the heroine out.

Two novels on the topic stem from the height of the crime wave. The thriller *Maximum Bob* features a plucky female probation officer who finds herself in mortal danger from a client while at the same time a married, much older judge comes on to her. Treated sympathetically, the heroine considers the job several levels be-

neath her (a sentiment with which most readers of the day would have agreed). Meanwhile, the urban novel *Slow Motion Riot* showcases a more traditional PO in DOP itself, stumbling through a midlife crisis about his work while also confronting a lethal client. Neither tale did much for probation's reputation.

By contrast, *The Odds of You and Me*, a 2017 novel in the women's fiction category, presents probation in a favorable light. It chronicles the last thirteen days of a young New Haven woman's eighteen-month probation term, which she had earned by repeatedly paying with bad checks. A single mom whose very motherhood stemmed from rape, she's determined to complete her term.

The woman's presumed antagonists include a probation officer who winds up her strongest ally, recognizing beneath the tough exterior her essential goodness, and testifying about it in court. The novel is a rare treatment from a client's viewpoint, leaving readers with an equally rare favorable impression of probation practice.

Meanwhile, a former New Orleans PO's 2020 memoir, *The Second Chance Club,* revealingly covered the more widely known practice of parole at greater length than probation.

The stipulations of probation provided the comedic theme in two efforts that mocked the sanction.

The 1978 BBC comedy series *Going Straight* focused on the travails of a convict released on probation—parole in American terms, but with application to what we call probation as well. As we've seen earlier, a scornful treatment of the practice pervades Britain as well.

Our bombastic hero of the series has a lot to explain to his probation officer as to why his job offer fell through—something about his missus who had obtained the offer having shacked up with the employer in the meantime.

"I thought your home life was stable!" exclaims the shocked PO.

"It is a stable, but the horse has bolted. Or in this case, the old mare."

Moving on, the primitive visuals and computer-generated voices of the 2012 short video *Probation Officer: First Contact* only add to the mirth in this dramatization of the initial encounter between an aggrieved PO and his clueless white supremacist client. The latter seems unaware that continuing to use and sell drugs, pimp his underage girlfriend, and keep a cop-killing pit bull guarding his house can earn him a violation.

"You can't search me without a warrant."

"Do you remember those papers you signed in court?"

"Yeah."

"Well, those were your conditions of probation. One of those conditions states that I can search you without a warrant."

"That is bullshit. I did not know that. My public pretender did not tell me that."

"If you did not like your court-appointed attorney, why didn't you hire your own?"

"What? Use my hard-earned drug money to pay for some sleazy lawyer?"

The video won many fans among the nation's officers—many of whom vouching that it rang true with their own experiences.

NEWS COVERAGE: Not typical cases, and disguised to protect identities, but representative of media disrespect all the same.

CRIME

Taping dog's snout shut gets him probation in Topeka

"It just got too much," according to Lamar Smith, 19.

The neighbor's bulldog had kept Smith awake for three nights running. "The owner wasn't even home. I don't know how the dog even got fed. All I do know is that no one could put up with that racket for so long."

Judge Kevin McCall could have put Smith away for two years. Instead, the judge was merciful and so Smith got off with 6 month's probation.

Idaho Falls English teacher gets probation for sex with male and female students

Susan McIntyre, 25, could not help herself. Her students were just too hot.

McIntyre was placed on probation yesterday in Idaho Calls Court. The judge could have given her two years in prison for corrupting minors.

East Boston woman on community supervision makes off with her probation officer's wallet

Cold-cocking chiropractor earns Florida man probation

FORT LAUDERDALE

Why was Denroy Jones so upset with Dr. Larry O'Neil? Could it have had something to do with the right arm he could no longer use?

Maine senior who tricked women into inserting his catheter gets probation

Biting bro's nose gets him probation
Caught him in bed with ex

Dwane Dickens, 32, of Terre Haute caught a term of five years' probation after he caught his brother Ezekial bedding his ex-wife—and reacted by nearly biting his brother's nose off.

FILM/TV/VIDEO: Sympathy and Mockery

Interviewed by a psychologist.

The PO, client, and the PO's son compare notes.

"What were you thinking?"

"It is a stable, but the horse has bolted."

Mayoral assistant (L) and Chief of Staff (C) interviewing the supervisory PO (R), who had recommended probation.

"If you did not like your court-appointed attorney, why didn't you hire your own—"

At the beginning of 2019, a possible corrective appeared on the horizon. The TV series *Jefferson County: Probation*—the brainchild of comedian Roy Wood, Jr., who had himself served a term for lifting credit cards to buy jeans while enrolled at Florida A&M—entered development. His PO, to whom he remains eternally grateful, pushed him to keep up his comedy gigs. Apparently, several characters were to be based on DOP personnel, with Wood playing a PO willing to bend the rules to help his clients. If it aired, the series might have proven a landmark in raising public awareness of probation, the dedication of some officers, and the struggles of its clients—even if treated lightly. Yet as if to prove probation's lack of popular appeal, the series never made it to airtime.

But stipulations might form the spine of other comedic efforts. For example, a tale could involve neither a clownish client as in *Going Straight* nor an unorthodox PO à la Wood but an agreeable innocent on probation, trying his best to handle anything dished out by his outlandish PO. This would be a riff on the celebrated Austrian drunk driving test in *The Man With Two Brains*: "'Become a Navy Seal? Do post-doc work on semiotics? Fix the New York subway?' Yo, these probation rules are hard."

Then there are the probation officer jokes.

There was a probation officer who found himself late for work during a power failure because he got stuck on an escalator.

How about the PO who broke both her legs ironing the curtains? She fell out the window.

Why do people take an instant dislike to probation officers? To save time later.

Beyond all these cultural representations, there are the vacation t-shirts, which if appropriately insincere do have the effect of placing the everyday wearer in the guise of someone on probation.

" IT KEEPS YOUR WHEELS TURNING."

FIVE
OUT IN THE WORLD

As the workshops continued, opportunities arose to extend the program's photographic output by conducting paid shoots of local businesses and regional events. Successfully completing these assignments would give the participants the self-confidence to go on to portray their own lives. Not simply relegated to slinging burgers for the minimum wage like so many of the justice-involved, they could earn money (if not yet a living) as artists.

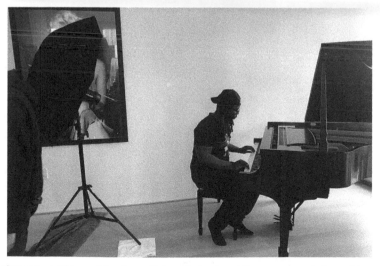

Park Avenue Pianos hired participants to shoot the company's brand image.
Photo: SFO/NeON

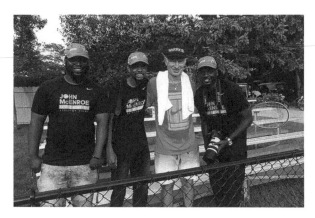

Photo assignment: Tennis Tournament. Photo: SFO/NeON

One steaming Saturday afternoon in the summer of 2018, participant photographers boarded the Long Island Rail Road with their cameras, bound for the tony Hamptons. Their task? Conduct a photo shoot of a tennis tournament benefitting the inclusion of underprivileged New York City youth in the sport's realm. One of the all-time tennis greats hosted the event.

Participants gathered to cover a City Hall press conference in December 2018 marking the independent confirmation of the value of NeON Arts programming.

Photo: SFO/NeON

Photo assignment: Fashion Show. Photo: SFO/NeON

And then, on a weekday afternoon in the late fall, DOP Commissioner Ana Bermúdez and a cadre of participants trooped uptown to City Hall to explain the value of the photography program to the city council in its massive nineteenth-century chamber adorned with paintings twice a person's height. A love-fest from the get-go, the hearing gave off such a positive vibe that councilmembers in other meetings came rushing in to investigate.

"All this smiling is not where the world is now," observed the chair. Members jokingly competed in offering additional funding—hoping for a mention in this text and requesting books for the council.

Kenneth in particular got their attention. Some hundred pairs of eyes focused on him like a laser. Some hundred pairs of ears strained to catch every word.

> One minute you're in a class in Harlem, and the next [the instructor] is shoving a camera in your hand and you're photographing the lead pianist for the New York Philharmonic at a private venue on Fifty-Seventh Street.
>
> It keeps your wheels turning, to be around creative people. That inspiration is kind of priceless to me, and it definitely has me thinking in terms of how I can take my craft to the next level—and about other skill sets I can apply to my professional life.

Yet the seriousness of the situation facing many clients provided a sobering subtext to the celebration. Discussing those the arts programming aimed to help, Bermúdez warned, "I can't tell you how many don't think they will even be alive in a week."

Endorsing the value of arts programming, the councilmember for the South and West Bronx offered a seemingly unorthodox viewpoint that appeared to strongly resonate within the proba-

tion agency itself, which had like agencies nationwide traditionally viewed its practice as providing a second chance: "Our young people need a first chance, because they've never been given even *one*."

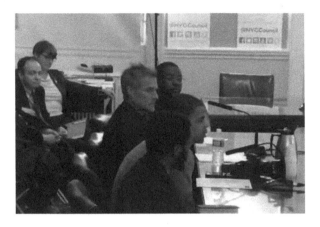

Commissioner Bermúdez (second from left) watches Kenneth (R) testify. Photo: NYCDOP

The chair summed up the meeting when the clock on the wall signaled it was time to leave:

> Every once in a while, something stops you. It's almost like the power of art itself. It's why a theater performance is so great, it's why a visit to a museum and looking at art is important, because it stops you for a second from the chaos of the world and it makes you think about why we're here, and what we're supposed to be doing with this time, on this Earth—us as elected officials, but also as people. This hearing is that moment. Wherever I was coming from, rushing from that luncheon, wherever I'm going now, rushing to

those evening events—this moment, these three hours, were really, really important.

Mostly, because of all the participants in the program who spoke and shared how it transformed their lives.

"Every once in a while, something stops you."

"I'M GOING TO GET MY APERTURES RIGHT AND PERFECT THE PROCESS."

SIX
THE PICTURES

A homeless woman lying on an East New York sidewalk.

A pair of sneakers hanging from a Bronx fire escape.

Three probation officers crowded into a client's apartment during a home visit.

Journey into a world many have never seen, invisible because these images of and by people on probation don't have sensationalist appeal. But that doesn't deny them higher powers. As a famous photographer noted a half century ago, the most banal aspects of everyday life can be imbued with compelling drama in the hands of the right picture-taker. What you see here you view not from the vantage point of a reporter routinely dispatched by a tabloid for a few shots enlivening yet another crime story, but through the eyes of New Yorkers who may have made one mistake (or through their neighbors' eyes). And so you will make their acquaintance as well.

What do so many of the photos that follow have in common? Optimism, joy, determination—in both the photographers and many

of those portrayed—even as supervision and menace color other imagery. Anyone serving probation has absorbed much of what life can throw at people. But none of the NeON photographers take this opportunity to complain; rather, they simply demonstrate pride in their lives and new skill, and an unstoppable resolve to get back to or remain on the right track. "I'm going to get my apertures right and perfect the process," Michael declared. "Then I can take it anywhere."

WORKSHOPS

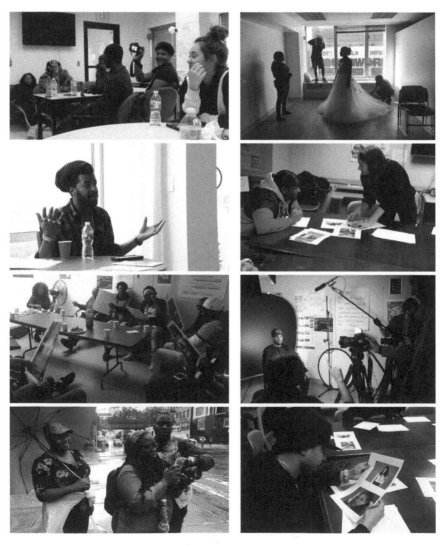

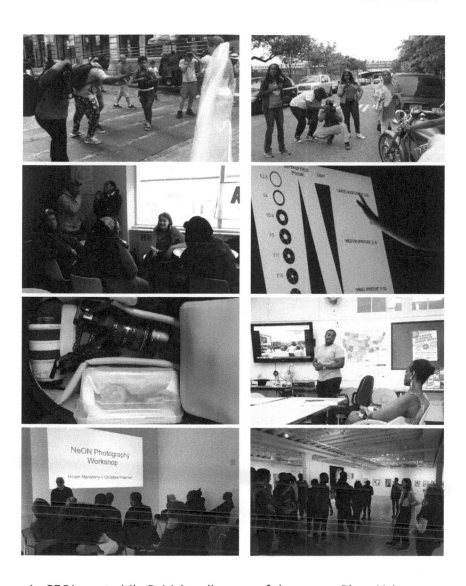

As SFO's erstwhile British colleague of the group PhotoVoice continues to argue, there are many ways of viewing images arising from "governmentalized" NGO-led projects such as this. There may be meanings beyond what SFO can detect. The floor, as it were, is open to all.

But what can be seen, as in *Project Lives*, remains less of an accusation than a plea for change, the work returning to the oldest of answers.

PROFESSIONAL ASSIGNMENTS

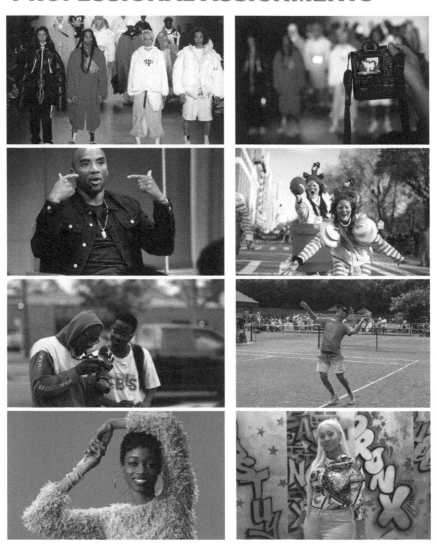

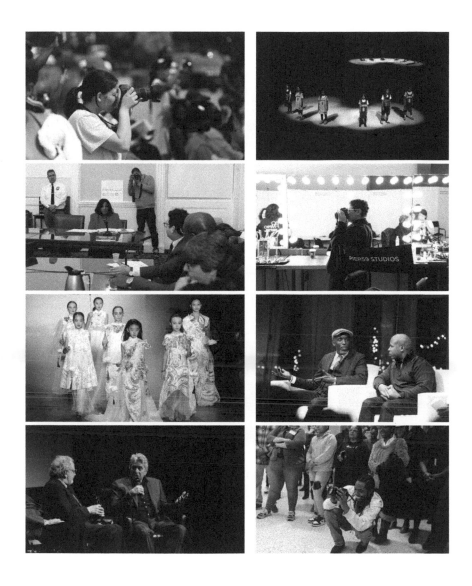

66
ALL I DID IS TEACH KIDS AND ADULTS HOW TO COLOR INSIDE THE LINES."

SEVEN
THE FRONT END OF CORRECTIONAL SUPERVISION

Focus groups arranged by the operative in Paramus, New Jersey over the Memorial Day weekend in 1988 had reacted with a collective start when informed of the tale.

Out on a 48-hour furlough, the lifer convicted of the felony murder of a Lawrence, Massachusetts gas station attendant had elected not to return, winding up months later in Oxon Hill, a Maryland suburb. Then, needing cash one day and the worse for drink, the escapee had sized up a light-blue ranch house as a drug den and broken in through a ground-floor window. It was April 3, 1987.

He had led a life devoid of progress, having been imprisoned for violent felonies in the '60s, '70s, and '80s. The operative on reading this record may have been reminded of the Major League pitcher toiling until two years ago just 46 miles up I-95 from Oxon Hill, the only one to have won a World Series game in each of three decades. Appreciative guffaws from the assembled New Jerseyans would have echoed around the cavernous meeting room in the black-windowed office building had

the functionary shared this fun-house parallel with a sly wink as was his wont.

But on August 20, 1983, the white Bay Stater pardoned by the governor in 1975 had confronted a father of three outside a Dunkin' Donuts in the Roslindale section of Boston. The former convict reached for his gun. This more harrowing tale would not be shared with the focus groups.

Now, with the weekend's results on the Oxon Hill incident in hand, the operative seems to have mentally directed the attention of the Massachusetts governor to the home invader. "By the time I'm done, the American public will think he's your running mate."

Probation begins with the breaking of a law—whether in reality or merely as perceived by the authorities. As that Orioles hurler would be the first to point out, it's not whether you actually beat the tag, it's whether the umpire spreads his arms or jerks his thumb.

Americans caught up in the criminal justice system for such an apparent act, whose offense a judge adhering to applicable statutes and guidelines deems severe enough to warrant supervision but not quite awful enough to merit jail or prison—and for whom community supervision seems a promising form of correction—wind up on probation. In general, the jurist follows the recommendation of the probation function itself, as we'll see. Like parole, probation involves supervision where the individual resides. Successful completion of the probation term releases him or her from the criminal justice system, although still leaving the person saddled with a criminal record.

In some cases, probation forms part of the original sentence, to be served following a term of incarceration. Another option occurs when pretrial probation formally dictates discharge from the criminal justice system when the term has been successfully completed or incarceration pending trial for the original offense

when not. But most often, probation substitutes for incarceration—a jail or prison sentence suspended by the judge in its favor.

Known by cynics as "getting paper," landing a term of probation remains preferred by most—though not all—to an actual stretch in the federal or state pen. To ensure compliance, those on probation must report regularly to the probation agency, while subject to unannounced home visits—the twin pillars of supervision.

Individuals fail their term for three main reasons: disobeying technical stipulations like passing a drug test or keeping an appointment; absconding altogether (often out of fear of failing a drug test); or actually committing another offense. Probation agencies report a violation of probation to the court, which takes it from there.

Technical rules have ballooned in some jurisdictions to two dozen or more. These may include all-but-impossible strictures such as associating with disreputable characters, and bizarre if not unconstitutional directives such as displaying a bumper sticker proclaiming one's sexual offense, or not fathering another child. For all those just beginning their terms who say to themselves "I got this," others wonder how they'll survive their first day. Even the privileged find the rules a heavy weight to carry around for years. Many of those lacking habits of responsibility ingrained by a middle-class upbringing, supportive parents, good schools, and non-menial jobs eventually find the burden insupportable.

In rehabilitative jurisdictions, run-of-the-mill technical violations of probation can simply lead to sanctions such as more intense supervision and/or a judicial reprimand. In a punitive jurisdiction, serious technical failures or absconding can involve a jail term prior to a return to probation. Punishment can even include a jail term along with a partial or full revocation of probation, involving imprisonment for part or all of the remainder of the sentence normally suspended on the original grant of probation. In this

instance, the nominal alternative to incarceration is transformed into a staging area or pit stop en route to lockup—or even a sanction that eventually leads to more incarceration than if probation didn't exist. Technical violations account for more than a tenth of state prison admissions.

Meanwhile, the substantive violation of another offense ordinarily leads to incarceration for the probation violation, even if served—as in New York State—simultaneously with the term for the new offense. Additionally, a partial or full revocation could still come on top of this. With revocation requiring proof not beyond a reasonable doubt but merely more likely than not, an individual acquitted of the new offense could nevertheless find their probation revoked. Probation violations in total feed mass incarceration.

The novel *The Odds of You and Me*, discussed earlier, dramatizes the possible complications. The heroine is determined to complete her probation term when she suddenly finds herself the only possible salvation of a man on the run from the law—the hero who had intervened after her sexual assault, perhaps saving her life. With only days left in her term, revocation was therefore beside the point. Ultimately the heroine dodges jail for the violation and earns probation on the aiding and abetting charge, even with the offense committed while technically on probation.

In almost all jurisdictions, probation terms cannot be lengthier and normally run much shorter than the maximum term of incarceration associated with the offense. They often extend between three and five years. Homicide, kidnapping, and rape merit a probationary alternative to incarceration far less frequently than other offenses.

ORIGINS

The practice started up in Boston in 1841. Incarceration itself—so brutal in places it would make Riker's Island, New York's infamous

penal colony, seem like a country club—had recently become normalized throughout the nation. A teetotaling shoemaker named John Augustus attending a police court one day wondered if a drunk about to be sentenced could be rehabilitated if shown kindness rather than to a prison cell. (This was an even harder obstacle to overcome when considering the kickbacks Beantown law enforcement received for every convict imprisoned.)

Quizzing the defendant, Augustus obtained a pledge that if saved from lockup, the drunkard would never touch alcohol again. The bootmaker then arranged with the judge to pay the man's bail and return him to court in three weeks.

It was no accident that the practice began among New England Yankees. The Bay State at that very moment was the hotbed of the abolitionist movement, the country's vanguard in placing those with mental illnesses in private and public hospitals specializing in their care (as opposed to behind prison walls), and among the first states to recognize the growing condition of poverty.

The founder: John Augustus.

When the convict duly reappeared in court, having gotten religion and pulled a 180, his reformist handler had effectively begun an 18-year career as the state's, nation's, and world's first probation officer; he even invented the term. At first, Augustus focused mostly on men with demon rum issues, so dedicated he put some up in his own home. (One wonders how his wife put up with that.) In addition, this PO compiled a record of success as a

bail bondsman that was remarkable in itself—all but a handful of almost two thousand returned on schedule. In contrast with incarceration's abysmal track record, most were transformed to the point of eventually leading upright lives, which led Massachusetts to enact the nation's first probation statute in 1878. The founder set each element of the practice in place: investigation; intake into probation (or, as codified later, into the criminal justice system itself for juveniles); and community supervision.

Little-known even in the probation agencies that today honor his name, Augustus would himself take some heat for endangering the community (naturally); corruption (which Augustus took pains in his memoir to disprove); and paying special attention to the youngest and most fetching of his female charges once he moved on from redeeming drunkards to rehabilitating prostitutes (an accusation he alluded to in his memoir). Shades of #MeToo.

Still, John Augustus proved a game-changing innovator. As is often true in such cases, he came from completely outside the field. In some ways, Augustus seems more akin to the tech pioneers of our own era than to the visionary philanthropists and social work pioneers to whom he is often likened. His invention would eventually separate itself from bail like the Voyager 2 breaking free of its booster rocket, embarking on a journey—in this case, not across the solar system but hopping first from one state to another, then to other English-speaking countries, then by the second world war to other industrialized nations, and now spreading even further yet.

Rehabilitation was baked into probation from the start. The deal was set: an individual redeemed, with lower recidivism in the future purchased at lower cost than incarceration, outweighing any new offenses committed during the term. For a century after the enactment of the Massachusetts statute, the arrangement held.

Until it didn't.

EVOLVING PRACTICE

As the twentieth century progressed, probation slowly and haphazardly professionalized. In certain urban jurisdictions, its staff transitioned from informally trained community volunteers into a cohort steeped in the diagnosis and treatment of troubled individuals. This occurred even as the practice remained the poor stepchild of the criminal justice system—ill-funded and all but unknown to the public.

Within New York's probation department today, many staff have a social work or educational background. All boast BAs, some even PhDs. "Tough with hearts of gold" is a cliché that nevertheless seems to fit most.

As for what POs do, few can have expressed the standard rehabilitative approach more succinctly than the probation chief of East Boston's district court upon his retirement in 2018: "All I did for thirty-four years is teach kids and adults how to color inside the lines." In 2012, a thirteen-year veteran of Ventura County, California probation crystallized her profession this way: "We're in the business of second and third and fourth chances." The retiring head of Nebraska's service declared in 2018 about her 43-year career: "You feel it in your soul. It is a passion." But for others not so much. Some officers wash out their first day on the job. Even a dedicated and caring New Orleans PO who appeared in *The Second Chance Club* had to call it quits after seven years, remarking, "People who can do that for twenty are freaks." Meanwhile, a Michigan veteran of forty-eight years recalled on his 2021 retirement how often he came close to packing it all in, the job taking such a toll on heart and mind.

A retired judge who we'll call Simon—troubled to this day by how the onset of statutory minimums had once forced him to send a Black college-bound teen away on an inconsequential gun charge—has had many POs appear before him. "A lot of their work is very frustrating because many probationers just can't get

it together. On the surrender hearings, I got a very clear sense as to when the probation officer had brought the violation just to get the probationer's attention, as opposed to when they'd had it and were saying 'Judge, I can't do any more with this person, he needs to go away.' I would pay a lot of attention to that difference in the PO's attitude."

AMERICAN PROBATION: Compare this imagery with today's snarky news coverage shown earlier. A different media perspective is possible.

Chicago Probation Officer Mary Finan (L) sharing telegrams from the public with a leader of university students' mothers (R), the groundswell of messages endorsing the argument of a Catholic cleric (C) for the rhythm method of birth control, 1934. This was possibly Finan's early inkling of a connection between unwanted babies and future crime. Roe vs. Wade was once a leading explanation for the ending of the crime wave in the mid-1990s.

Photo: Possibly N.E.A./Catholic Physicians' Guild

Probation Officer Robert Miller (R) escorting Helen Bulevski (L) to prison, 1935, for violating stipulations— whether technical or substantive—or for simply absconding.

Photo: Unknown

Convicted of second-degree manslaughter in the death of her illegitimate newborn, Elizabeth Smith, 18, of the Bronx (C) receives the good news of a probation sentence, 1936. She was to be placed with a "fine woman who has a lovely home."

Photo: Possibly N.E.A./ACME

Patricia Mann (L), a New York City waitress convicted of DWI—then repeatedly violating the probation condition of sobriety—escorted to jail by a court officer (R) in line with Mann's preference, 1940.

Photo: *Daily News*

Wholly professionalized: Probation Officers Ray Hulbert (L), Edward Taylor (C), and Leonard Probst (R) confer at a New York State conference, 1945.

Photo: ACME

At times, probation took on a higher profile than its usual standing within the criminal justice system; here, the Massachusetts governor (fourth from left) swears in a new Probation Officer, George Skelly (third from right) for the Boston municipal court, 1954.

Photo: Unknown

Milwaukee Juvenile Probation Officer Helen Lange (C) presenting one of her last cases in the children's division of county court, 1962. She was then transferred to adult probation work.

Photo: *Milwaukee Journal*

In a case of probation included from the outset as the follow-up to a prison term, Kansas City right-wing terrorists convicted of violating federal firearms laws receive sentences of prison followed by community supervision, 1967.

Photo: AP Wirephoto

The redemptive power of probation could attract clerics to its ranks; for example, Chief Probation Officer Sister Rose Paula exiting the West Roxbury district court in Massachusetts, 1976.

Photo: Ray Lussier

Pointing out a stipulation, Probation Officer Robert Johnson of Clackamas County, Oregon, orients a new client to the rules, 1978.

Photo: *The Oregonian*

Cleveland Probation Officer Leslie Bass (L) counseling a client, 1982.

Photo: *The Plain Dealer*

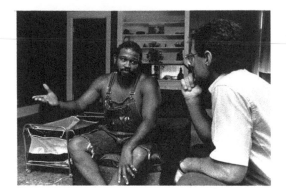

Jeff Bland (L), 32, receiving stern counsel from PO Todd Zangel (R) during a home visit, 1990.

He had begun slipping back into his drug habit while on post-incarceration supervision after serving a decade for armed robbery.

Photo: *Milwaukee Journal*

Unannounced home visit by Cayuga County (NY) probation officers, 2018. This is often the most dangerous moment in a PO's day.

Photo: *The Citizen*

As probation grew more rigorous with professionalization, its clients began to view it less favorably when compared with incarceration, especially with jails and prisons no longer the hellholes they were at the time of probation's founding. One 24-year-old Gotham waitress—whose bouts of alcoholism frequently encouraged her to drive off in cars that were not hers—so resented POs who "hound you to death" she asked the judge to send her to jail instead of adding more time to her term. (As we've learned, he could have done both.) "You can't keep your life your own," she cried, stamping her feet. "Probation is a racket and I don't want any more of it." She was not the last to express such a preference down through the decades.

TAKING OFF

As shown in Figure 2, below, judges offered probation to a moderate number of convicted adults as late as 1940. By 1965, the practice had achieved a dominant position in the criminal justice system, which it has yet to relinquish. Accounting for half of those under correctional supervision that year, probation rose to a high of two-thirds of the total by 1975. But it was in 1980, as a result of the crime wave that had begun in the early 1970s (and would extend to the early '90s) that probation began to explode even as jail, prison, and parole volumes took off.

Reaching a peak of 4.3 million in 2007, probation volumes then finally turned the corner (even while representing an increasing share of a diminishing number of arrests), with jail and prison volumes starting their own descent soon after—all this in part a long-delayed impact of the crime wave's precipitous fall. Five out of six individuals convicted of a crime were still winding up on probation until the pandemic began dropping numbers sharply lower.

But we remain in an era of mass probation as well as mass incarceration.

Figure 2: Americans Under Correctional Supervision 1935 – 2020

Source: Bureau of Justice Statistics

Probation for juveniles has generally followed the adult curve. Volumes rose from four hundred thousand delinquency case outcomes in 1985 to seven hundred thousand by 1997 before dropping to one hundred fifty thousand in 2018. The decline reflected the fall-off in juvenile delinquency itself rather than any abatement in the sanction's intensity as a correctional alternative. While offered in 1985 to fifty-seven percent of those convicted, probation accounted for sixty percent of adjudicated outcomes in 2005 and sixty-three percent by 2018. (Placement in juvenile residences in each year represented about a quarter of the dispositions; other, lesser sanctions, about an eighth.)

THE WHOLE ENCHILADA

And so we arrive at the present day. The 3.1 million Americans currently serving terms of probation (including barely fifteen thousand at the federal level, who inhabit the best-funded and, not coincidentally, most successful realm) account for a majority of the 5.7 million under correctional supervision. They comfortably outnumber the combined 1.2 million Americans serving terms in state or federal prison, 0.5 million biding their time in local jails, and 0.9 million out on parole. The least-known arm of the criminal justice system, the two thousand probation services operate out of the judicial or executive branch of government, at times combined with parole. On a per-supervised-person basis, probation costs less than one-twentieth the same term of prison. In spite or because of the imbalance during most of the last century, incarceration monopolized spending increases on corrections in response to the crime wave. The growth of the correctional population even after crime began to plummet in 1993 illustrates the increasing intensity of correctional punishment up until only recently.

Six in ten individuals on probation committed felonies, the remainder misdemeanors, with the combined total completing their terms successfully somewhat more than half the time nationwide. In almost a quarter of the cases, probation proves a failure—whether by incarceration, absconding, a discharge to a warrant or detainer, or another contributing factor. Other outcomes (death aside) remain uncertain.

Figure 3: Offense by Probation vs. Incarceration 2022

Sources: Prison Policy Initiative and Bureau of Justice Statistics

Figure 3, above, shows that (as one would expect) violent offenses represent a smaller share of those adjudications ending in probation than of those leading to a jail or prison term. Judges have been less authorized or inclined to allow violent individuals to remain in the community. Meanwhile, the grab-bag of offenses outside the four main categories accounts for a larger share (with many probation agencies facing challenges in reporting misdemeanor offenses in particular).

In Figure 4, below, the wide variety of offenses meriting probation can be compared with those leading to jail, state prison (mostly violent crime), and federal prison (devoted overwhelmingly to drugs and public order offenses).

Figure 4: Offense by Probation vs. Incarceration Type 2022

Sources: Prison Policy Initiative and Bureau of Justice Statistics

DOWN AND DIRTY

Cheat on a test and only your school and parents will care. Bend the rules on car emissions tests and you'll poison the planet. Volkswagen executives conspired to cheat like that for at least six years before the German firm took a plea bargain in 2017. Along with paying a $2.8 billion criminal fine, the carmaker bought itself three years of organization probation—a sanction added to the US criminal code in 1991, enforced by an independent monitor rather than a PO. (The essential

condition? As with individuals, not breaking the law again.) Five years later, American manufacturer FCA US (formerly Chrysler) paid $300 million while sentenced to three years of organization probation for a similar if briefer cheating spell during the same era.

"I'M GOING TO USE PHOTOGRAPHY TO HELP CHANGE THE WORLD."

EIGHT
PARTICIPANTS

We've met a few in Chapter One. Let's continue to get up close and personal with a handful of the New Yorkers who signed on to this adventure. While many are now serving or previously served a probation term, others are simply neighbors. Their communities—so long denied access to opportunities—helped create the current predicaments of the justice-involved, leaving them unable even to take their personal safety for granted; meanwhile, certain residents served as their primary victims. Yet those on probation look upon those neighbors in the program (a third community cohort) as their key supporters, viewing their simple presence as assistance. The photographic achievements across-the-board owe much to such group solidarity.

THEIR STORIES

Many on probation seem to have it together—long past their days of behavior that had gotten them into trouble. The thought occurs that even with two strikes against them, having a supportive network when young—as some of their peers enjoyed—might have let them avoid so much. One never knows. Even someone so blessed by his upbringing as Henry (who we heard from earlier)

acknowledges "As I grew older, I kinda strayed to the wrong path," his confession a faint echo of the famous opening lines of Dante's *Divine Comedy*: "In the middle of the journey of life I found myself in a dark wood where the way was lost"—and, as we'll soon learn, applicable in a way to the practice of probation itself.

Yet participants' achievement in this program went far beyond learning to color between the lines. NeON: Photography had recruited DOP clients by offering them the opportunity to not only obtain a marketable skill but change the very image of probation itself in the public eye. Most US probation clients who could benefit from such a rebranding live very different lives in very different realms from the participants themselves; they range from a small-town white Minnesotan who was found guilty of garden-variety assault to a high-living former State Department official who illegally lobbied for a foreign country. And so those who enrolled in the photography program had in some way extended a hand to their compatriots, if unconsciously.

Further, what neither the participants, nor the probation agency, nor Seeing for Ourselves had anticipated was how much photography itself would change the photographers' lives. Their documentation of their world showed them that they could not only use photography to influence the public image of people on probation—the task at hand—but also employ mastery of the camera to influence others going forward to all kinds of good ends. As a TV reporter covering a gallery exhibit would notice, they now saw themselves—and their world—in a whole new way.

And for at least a few there was an impact even more profound. Perhaps more than any of the arts, photography drives home how each of us sees the world differently, that we each have our own perspective—a lesson reinforced by the chairs-in-a-circle setting the program borrowed from restorative justice. It would be a revelation to some forced by circumstances to put their own needs first and foremost and provided perhaps the strongest steer on the route to redemption.

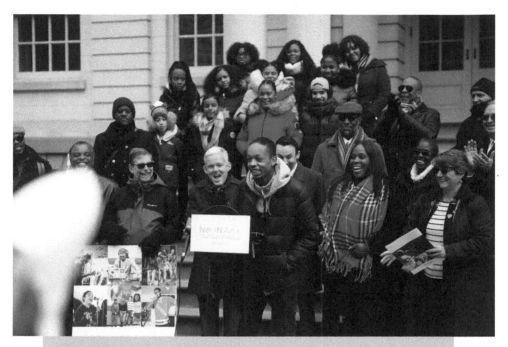

DYLAN

Big Dreams
Bedford-Stuyvesant

Transitioned to Teaching

The quicker we can grab these kids off the street, the less crimes, the less trouble, the less you wake up in the morning with the news that kids are missing or kids are dying or adults are doing whatever they shouldn't do.

Right now, if we don't change the world, who will?

As for me, I want to get into acting. I want to do a film and also work behind the scenes.

I want to also come out with a Zodiac clothing line. I want people to see I do both art and photography; they're in the same lane.

And I want to show my family that I'm trying to make a living, because I was messed up back then. I didn't listen to nobody.

I feel like this is my second chance—new things, opportunities, new doors opening. I started from the bottom; now I'm at where I'm wanting to be at. I'm going to keep God in my hand. I'll keep praying.

I grew up in Hempstead, Long Island. Back then, I didn't care about nothing. I just wanted to live life. I didn't have nothing.

My father's from Jamaica. I don't want to say he's strict, but he wants to make sure I have a better life than him. He worked in a warehouse; now, he does construction.

He was telling me to graduate school, go to college, get a good job. I understand that, but I want to do what I want to do. And acting is actually what I want to do, and if I don't do that, I can do film—I can be one of the big directors and shoot. A camera tells everything.

He's getting old, and it's going to be my turn to take care of him instead of him taking care of me.

I'm also doing this for my mother. I love my mom; she bailed me out of jail the first time, so I just want to show her I'm more than what I used to be.

And I have a niece also. This is, like, my chance to show her, "Your uncle is doing big things."

My little brother looks up to me. The world is changing; now it's what can I do for him or what can I show him? So he doesn't have to go through the experience that I went through. He's almost at my age when I was getting in trouble. I don't want the same thing for him, so I want him to see that his big brother is more than just being a bad person.

So I'm doing this for my family.

I meet with my probation officer once a week. She knows what I'm doing, and that I'm now a mentor to others. I was a mentee and turned into a mentor! I really want to help these kids.

What I say is, "You have to change. Maybe not the first time, but if you make a mistake, learn from it. Practice makes perfect."

I want to show my probation officer that I'm not just a criminal. I don't want to be labelled that way.

RHAM

The Mentor
Harlem

I was raised in Newark, and we then moved to Mott Haven in the Bronx in 1994 when I was eighteen. From one wonderful community to the next!

I had a really good home life. My mother was an educator—she was a teacher. My dad worked in construction; his specialty was brick masonry work. I have three brothers and one sister, who unfortunately passed away many years ago—a case of domestic violence.

Newark had local gangs back then. Streets fighting different streets, based on where you lived. But it also had a superb school system. And even the tough guys were very educated. They all had their degrees!

There would be three or four schools in a community, whereas in New York a community the same size might have had a single overpopulated one. So I got my high school diploma.

I've always worked in social services for youth and public service. And then became a mentor for the probation department.

I was on probation many years ago when I was 20-21. I served a five-year term. But it was a different time than today. All the wonderful programs that are available now for participants, I don't know that they were present then. The system was, basically, you were given the opportunity—and if you messed up, they had a place for you to go. I don't know if restorative justice was a piece of the plan. But the two officers on my case, they were wonderful. They did the best with what they had.

I checked in weekly at first, then graduated to biweekly, then monthly. But still, working that into my daily life? Oh, my goodness! That was challenging. It was a gift and a curse. I was lucky to get a job. And I was also so fortunate that my probation office was about seven minutes from my job. But then my boss and I took lunch at the same time, and I was worried he would see me coming out of the probation building. But I managed to keep the job.

I became a mentor in 2013.

One of the main things that we do on a team is developing a positive, healthy, adult relationship with the mentees. They're in the predicament they are in because of a relationship they had with someone else who probably was not the best or even a positive influence—someone who had asked for a favor that was agreed to. We need to redirect that type of thinking about the short term, and have them focus more on the long term, like someone who can be successful.

I work with one young man whom I never asked why he was on probation. He's very dependable, open to new experiences, and loves giving back. He's also transparent in terms of sharing his feelings. When we were walking to the train after he spoke at the program's gallery exhibit, he said, "That was the best experience I've ever had in my life. I felt like somebody, I felt like somebody really important and I've never felt that way before." I was grateful for having been allowed to share that moment with him.

FRANZE

Five Years
Brownsville

Because I had just come to the country, I didn't know exactly what probation was, but I was falling into a trap that would follow me for the rest of my life.

At first, probation was a scary place, because the probation officers that were there the first time I went in 2014, they made it such as kerosene, that upon entering the door you just wanted to leave as soon as possible. They began threatening to take away your freedom. You've got to go do this, you got to go do that. So it was kind of tense at first, and I wasn't really relieved by having a conversation or dialogue with the probation officers because I didn't know that probation was actually something like a healing center for you to go to rehabilitate. That information wasn't being presented or the environment was never like that.

So for two-and-a half years, that's what it was like. I also had issues with my surgeries. I was taking oxycodone and Percocet. They asked me on probation if I do drugs or anything. I'm like, no—but then when I did the test, it came up. I'm taking medication; I took it to them and I told them. It was, like, okay, so that's it.

What I started realizing, though, was that I had issues.

They're like, "You want to go to a rehabilitation center?"

"I'm not sure." I went there two months later.

The lady said, "You don't need to be here, sir." I got off that.

Immigration saw that I was a green card holder. They stated, "You violated your permit." So I had to go to the immigration detention center for a period of time, which was like seven-eight months. That was the only time I was absent from probation. When I went back, upon entering the door, the environment was totally different. The atmosphere, the probation officers, everything was totally different. That was when they introduced the NeON.

The probation officers were more sociable. They're not just these hardcore order-ing-about types. They started figuring out ways they could help you to make this thing much easier for you. Hence, I started to open up to my probation officers and they started to introduce me to programs. I did take the Free Verse poetry program; it was a nice way of expressing my frustration with all the things I've been through. The director was very good. These poems were published in the Free Verse collection:

Blessings in Disguise
Probation: a blessing on
the low.
Angels in disguise,
our POs.

You've been there before,
It should be easier
the second time around.

How could I
live beside you
for six years and never
say hello?

You got pregnant on our block
without even showing.

On the street of not knowing
You never know where you're
going.

But then, after four months,
they introduced another

program, the photography class.

I had the love for pictures, but I didn't understand them. I didn't know that a picture could be a thousand words until I started the class. Now, I'm able to read pictures without even looking at the subject.

This program has given me a platform; I've never had one before. It gave me a platform to showcase the work that I've done. The viewers like it. It has me wanting to pursue photography; it doesn't even have to be a career, but just taking pictures to capture that one moment.

I got a five-year probation sentence and I'm almost complete. I get off January 1. So after that? I spoke with my Probation Officer. I would like to see if I can be a part of the probation system. Just be someone who was on probation, who understood what it was, where I could apply some of the changes that actually worked with me. So that's my game right now.

I grew up in a single parent home; my father was in and out. He was a carpenter. Four siblings. My mother was a home aid. So we were a well-rounded family.

I became an assistant chef in America. Before that, in Jamaica, I had eventually taken on the carpentry work of my dad.

TODIYAH

Getting Started
Bedford-Stuyvesant

I grew up in Brownsville. That's where I graduated from high school. I'm learning barbering now. It will be my first real job. Knowing photography can help even this!

It's a rough environment in this part of Brooklyn. There's always someone tougher than you are. The police are kind of helpful to the community, but some see us as having a stigma and harass us.

TAQUAN

Back from Tennessee
Bedford-Stuyvesant

Transitioned to Teaching

Photography has been a life-changing experience because I see things

differently. Things are more fulfilling, more there; before, it was just vague. So now it's like, alright, I can see that, I can look at a park and see it's more than just an empty park; there's more to it. If a

career opportunity came up, I think I would take it, just to see what happens with it, because I'm really into it now.

I'm a mentor for kids that are on probation, so if I could show them to pick up a camera and not a gun, that would definitely be helpful to my job—and I've already been putting it out there like that.

"You could pick up a camera and shoot some pictures. You don't have to pick up a gun and shoot somebody."

It's kind of working. It's coming along.

At first, I was a camp counselor for one of the services that treats drug addiction. My supervisor suggested it. I had never thought of being a mentor because I know I'm not perfect. But this is my third year, and I love it, because it's giving back.

I've been locked up before. If I could stop them from making the same mistakes I did, that's cool. If I'm talking to twenty people and one person listens and goes this way and not that way, then I feel like I've fulfilled my job.

After coming back from Tennessee, I did a custodian job at first. That was my first job coming out of prison. A friend of my mother works with Good Shepherd Services. And she was like, "We have this opening for a camp counselor."

So that's what I did at first.

I grew up in Brownsville and moved to East New York when I was about twelve, thirteen. I've lived in Baltimore, different states.

Coming from the projects is challenging, because if that's all around you, then that's all you're going to want to do. If your closest friends are in a gang, you're going to eventually want to be in a gang. If all your friends are dealing drugs, you eventually gonna deal drugs because that's what's around you all day, every day.

When my own clients come in here, with their issues and problems, I don't judge them. It's, like, "I know what you're going through, but I can show you where you can still be the person that you are. You can take this route and show

people how much potential you have. You can add and subtract money, but you don't have to use that dealing drugs. You can use it in a job, you can become a cashier. You don't have to do the illegal stuff to be cool. You don't have to do the illegal stuff to be known. Be known for something positive.

"Be known for being that one person in the neighborhood who gathers up all the young males and females in the neighborhood and has an open discussion on Fridays. Or something like that. You know what I mean? You don't have to be the person that's known because you got a gun."

Once they see that I can relate, once they see that I've been there, once they see that if I haven't seen them in two or three groups, I'll come to their house to make sure they're okay—then they're, like, alright, there's somebody who cares. A lot of them join gangs because they feel nobody cares. Or there's family issues, there's issues in the household. So that's the first thing they do.

"The gang will protect me. They gave me money; they hold me down. So I'm joining the gang."

But we here show them that you don't have to join a gang, you can take another way.

My own father wasn't there. I just met him at twenty-five. But my mother, she was the male and female. What I mean is, she taught me to consider my caring side, my considerate side. The side that's the streets, I had to go to the streets to learn that. So it was the older people around me who taught me how to maneuver in the streets.

My mother, even if she didn't have it together, on days when she was struggling, she made sure that I didn't see it. And I always had more than the average kid—I went on trips, I've gotten anything I wanted. She made sure if it was in front of me, she had it, she could get it. So my upbringing was good.

I went to school in Brownsville. My high school was a science skills center, in downtown Brooklyn. But that's kind of when I was

going through my little phase; I wanted to be a gangbanger, I want to be it: Mr. Popular.

So I went from dropping out of high school in New York and ending up moving to Baltimore, where I lived with my aunt and uncle. And I kind of was on the right track, but then met the wrong people again, and ended up dropping out of school there.

Eventually I went to Delaware Valley Job Corps. I didn't finish my trade, but the first thing I had to do was to get my GED. And then I came back to the city, I was doing all right.

And then my girlfriend at the time, who is the mother of my daughter, she was having issues at our house, so she was like, I'm going to live with my brother in Tennessee until I get on my feet. I was also going through my own personal issues at home, so I felt like it was a new beginning for us.

So I just went, was doing good at first, got into the wrong things, and this time it was like, "All right, you doing too much. Let me sit you down before you do anything really drastic. Let me sit you down and show you this ain't it."

So I sat down for four years and once I came home to the city, I haven't been in trouble since. It's crazy that I'm in this line of work now because out of my group of friends, I was always the one saying "I don't think we should do this, we'll get into trouble." But still ending up doing it anyway!

I'm saying to a whole bunch of teenagers and young men, "Don't do this! It won't work!"

Telling me not to do something had made me want to do it.

So I'm not telling them not to do it, but trying to teach them they don't have to do it. That's my goal in life right now. I want to see change. I'm sick of coming out of my building and just seeing the same thing. I'm sick of seeing the older ones not really teaching these younger ones that they don't have to do the thing they're doing. They're more condoning it. If I could make a difference in one area and it spreads, then job well done.

MOSHELLE
Charismatic
South Bronx

I grew up in the projects—in Queensbridge.

I got three years' probation. They understood I wasn't a criminal; I had graduated college: Plaza College in Queens. But I'm here like so many others because I pled out. Most people feel pressured to plead guilty to a lesser sentence or probation.

After being told by a professional lawyer there is no way you would not be going to jail if they take your case to trial, most people—including myself—opt to simply plea out. Some people even plead out to felonies. Some have to actually register as a sex offender for crimes they did not commit.

There is a lot of talk about whether or not probation should even exist in the justice system. In my opinion, it absolutely should. Probation is a means to an end. Sometimes people make small mistakes, are in the wrong place at the wrong time, or are simply unaware that a certain act is illegal. In these cases, and some others, probation as an alternative to being locked in a jail cell surrounded by harsh criminals is absolutely necessary.

Statewide, probation needs to be crafted and perfected as a functional system that not only supports those who are in it but helps them find

and learn new alternatives to making a living that do not consist of breaking the law.

In some states, you have to pay to be on probation! As an innocent first offender, I cannot even fathom such a fate. Just the fees here in New York City are a problem for me, with three kids. I don't have $380 lying around.

And going to see your probation officer, even here, has been humiliating and degrading. You feel as if you are a school-aged child—while those who are school-aged are made to feel like a toddler. You are seated before a stranger who knows nothing about you other than what is put before him on your rap sheet. You feel judged, and so become insubordinate, right away. You are then scolded and asked why you are not living up to the standards of the computer-generated plan for your life—all before being asked to urinate (while they watch). He then instructs you to return the next week to

do it all over again. You now have to go through the week with the pressure of trying to find a job with a conviction on your record. This in dire hope that someone will hire you—because if you don't comply with your officer's demands from his computer-generated paper, you're going to jail.

And that's where I almost wound up last week over a simple misunderstanding. I am a single mother who was recently living in a New York City shelter with my three children. After a bedbug breakout, I was in a frenzy to move. The local market simply does not have three bedrooms for the price I was allowed with my voucher. And so I was forced to find housing in Jersey. I told my probation officer—but the next time I reported in, I was told I was in danger of being violated for moving out-of-state without permission.

What saved me that day is what I feel has the potential to save, help, and uplift all

those on probation. The Neighborhood Opportunity Network Arts program.

If I did not have a track record as a NeON participant who works and takes care of her three children, or my probation officer and her supervisor were not compassionate to the fact that I simply didn't know better, I would have left there that day in handcuffs.

Furthermore, NeON Arts changed my experience at probation from one that was humiliating and degrading to one that has been actually something I look forward to. What I once thought was going to be three years of mockery was transformed into three years of lifelong connections and a network of people who really wanted to help me be the best version of myself possible.

All probation systems should be focused on giving its participants the tools and opportunities New York City does with its NeON Arts programs. It could be the

difference between a single mother/photographer and a career criminal with three kids, which is what I would look like on paper had I gotten violated that day.

My son is fourteen now. He's a really charismatic kid, very much like myself. They always say you get it back with your kids. He's going through stuff now, and I tell him there are certain ways to handle things. He's a big Black guy, bigger than most police officers already. "You can't afford to have anger issues—you'll scare them."

I'm a poet. I'm enrolled in DOP's Free Verse poetry program as well as the photography course. The guest lecturer in photography last week was the City Hall staff photographer; he is a poet himself. He understands me so well, he overstands me. His eye is like mine, looking at a hot dog stand and seeing it's like a confessional. So it's poetic justice that I'm taking this course. And now we're doing the captions.

Our teacher is amazing.

ERIC

A New Man

Bedford-Stuyvesant

I did a photo shoot with a famous pianist with a Steinway!

The program changed my life. It made me into a better man—into the man that I wanted to be.

I was born in the heart of the heart. I call it The Jungle. From Bed-Stuy, born and raised. There's nowhere else, I think, in the city, that's more dangerous.

Like when I was growing up, we used to call Bed-Stuy the greedy and the greedy.

I was a menace. I was the person to be outside, wilding with my friends, beating people up for no reason, stole whatever we wanted, running away from cops.

If you're not from Bed-Stuy, don't come here, because you would not want to live here.

It's things that happened in my neighborhood that I've seen and it wrecked my life. And I'm glad I got my life back onto the right path.

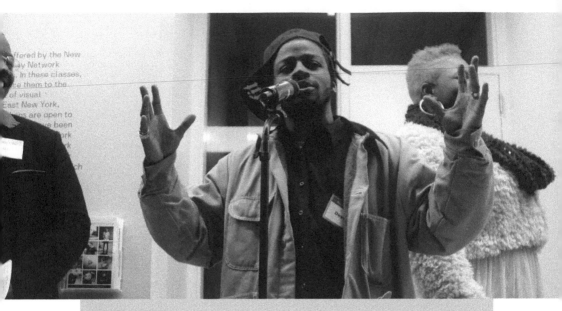

DEVONTE

**Words to Pictures
South Bronx**

I took pictures with my phone, but I never had an opportunity to professionally take pictures. So this program was life-changing. I'm like, yeah, I'm doing this! And on top of that, I have siblings, so I wanted to make a good impact. I wanted—when my brothers and sisters asked me what I do—to be, like, "I do photography for the arts."

Where I grew up, we didn't have this opportunity. You don't come across opportunities like this. It's either you do something wrong and get caught up or you're put in a predicament you can't get out of.

I was doing poetry and I didn't want to keep myself in one spot. I wanted to expand. What else can I do? I know I'm an artist, I know I'm a poet, but I'm capable of doing something else, because creativity is shown in so many different ways.

With photography, I have the opportunity to express myself without having to talk.

You can take pictures to express your emotions, so

you don't have to react to violence or do anything negative.

I come from such a crazy background, so I like to put that into my pictures—but make it look in a beautiful way. I took a picture of a Lamborghini. Where I come from, there's no Lamborghinis in my neighborhood. So I decided to take a picture of that. Show you I can't afford something like that, but I still love the beauty of the car.

The program gave me a different outlook on life. I've been able to see that you don't have to always stay in the hood and do the same thing and get yourself caught up in things that be hard to get out of. So now that I'm able to express myself in photography, I've been successful in doing greater things for myself.

If you don't have a community, you don't have no foundation.

In the classes, I was able to see creativity in others' photography and where they came from. Like the young lady from Barbados, she took a picture with an American flag behind her. It was a big thing for me because she's not from here. So I felt like she was showing, "I have respect for the United States. I love America, you know?"

TAVEL
**Back from the Bay State
Bedford-Stuyvesant**

What I notice about myself after the program is how I look at things differently and everybody has a different point of view.

There was a lot of negativity around here in the part where I grew up. Like in Brownsville, there's a lot of negative—you hear about the danger, like kids taunting other kids. That wasn't really the case in Massachusetts. People weren't out to get each other. So over here in Brooklyn it was like you have to watch your back. I had to become a different person.

I had to become more alert and more cautious about people. Basically, the way I trusted people, I had to tone that down and just be more and cautious. I had to watch every move I made—and watch every move everybody else was making.

I was miserable. I was depressed, I was looking at things through a stained lens. So basically, this program helped clear my lens. It helped me see my future better.

It helped me even if I can't see my future, because it helped me plan and see different points of views on the obstacles that I've been going through. Like how to look at things differently and take it from a different angle.

I'm going to use photography to help change the world, in a way.

People think that circumstances just happened to them, negative circumstances has happened to them. So I want them to understand that it's their actions that's causing the situation. I feel like I could do that in my photography work. I could inspire people to go down a more positive path.

PELRIQUE
Family Ties
Bedford-Stuyvesant

I started back in October when my daughter mentioned that she was in a photography class and she invited me. So, I decided to come, and since then I've actually enjoyed it. I didn't know anything much about photography. Just snapping a picture and that was it. I've learned so much since then!

Now I find that when I'm walking or when I'm driving, I'll see something and I will stop and say, you know what? That's a good picture. That's a good picture there. So, it's looking at things differently.

VERNEL
New Horizons
Bedford-Stuyvesant

I heard about NeON: Photography from my cousin. She told me there was a gallery showing. So I came through and was so amazed about some of the pictures. There were photos you would see in a newspaper or a magazine or in this day in social media or on the internet. I asked, "Where do I sign up?" As my mother says, expand your horizons.

Community to me means togetherness. We stand together!

LEO
Starting Over
South Bronx

Nowadays, we're so caught up paying bills, and making something of yourself in this life, it seems the more you go on, there's more competition, more dilemmas, more obstacles.

So I like to focus on the things that—when you stand still for a second—actually make all that go away and make you appreciate the moment that's at hand.

Before probation, I wasn't really using my time properly. I was kind of involved in negative things here and there.

I'm really fond of nature photography. I like to surround myself with the woods. Photography has given me a new outlet to do that.

It's a second chance.

66
THEY WERE ALWAYS UNDER-APPRECIATED AND UNDER-FUNDED."

NINE
CRIME, PUNISHMENT, AND AMERICAN JUSTICE

Where does probation fit into the American criminal justice system? The answer: more widely than many suppose.

Figure 5 (following page) shows the adult process, highlighting the role of probation. Here, the function includes the two key roles of pre-sentence investigation (PSI) and supervision (via reporting-in and home visits). Intake into supervision might be considered a third component. The PSI examines the offense, the victim, the circumstances, the background of the individual—anything the probation function determines bears on the proper sentence to be recommended to the judge.

Meanwhile, Figure 6 (page 121), displays the juvenile flow. Probation forms the cornerstone of the juvenile justice process. The function handles intake into the system, including the investigation corresponding to the pre-sentence investigation of adult court, with almost two-thirds of those convicted adjudicated to probation as opposed to placement in a juvenile residential facility or given another sanction. Probation terms for juveniles do not reflect strict sentencing but rather conditional supervision, dependent on their behavior.

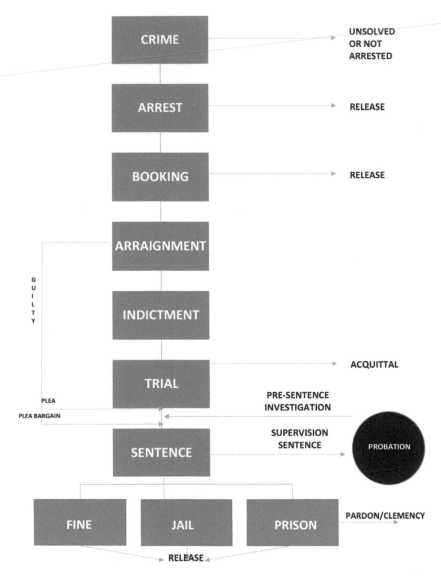

Figure 5: Simplified Criminal Court Process
Showing the Typical Role of Probation

The very first case of a retired judge we'll call Paul had led him to offer probation to a defendant he only later discovered was the son of a local Mafia chieftain. Every other jurist had ducked the court assignment. Paul thanked his lucky stars for his decision from that point forward.

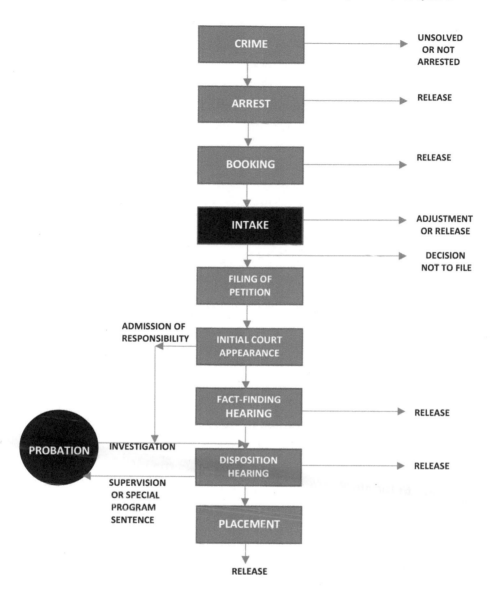

*Figure 6: Simplified Juvenile Court Process
Showing the Typical Role of Probation*

As both a defense lawyer and subsequent jurist, Paul came to value both the federal and local probation arms. "If you as defense counsel went to the federal judge and said, 'I think my guy deserves probation,' you had no chance. If you went to the judge and laid out the reasons for probation and how it would be struc-

tured, and you got the federal probation office to say, 'We've checked all this out and it looks good and we would recommend it as well,' then—as often as not—most of the federal judges would lean in your direction rather than simply honor the time in prison that the US Attorney's office wanted. And that was terrific."

Meanwhile, Paul viewed the local probation office as beyond dedicated in its supervisory role. "They almost all worked weekends, usually doing home visits. They were always under-appreciated and under-funded.

"Nobody paid any attention to or read anything to do with the probation department unless someone screwed up.

"Then," Paul concludes, "all hell broke loose."

Two attributes of the basic system call out for attention at this point. One should now be obvious (if unknown to almost all Americans). The other, probably less so.

First, what can be readily concluded from the two flow charts is the outsized role that probation plays. In many jurisdictions, it not only supervises clients but also represents the informal sentencing arm for almost all found or pleading guilty (including some accepting guilt as the result of a plea bargain). Judges accept the recommendation of the PSI or investigation in the vast preponderance of cases. The point bears repeating: the probation function effectively determines a great number of those sentences—insofar as allowed by statute and sentencing guidelines—that we attribute to the judge's discretion.

Occupying part of probation practice since its founding, the PSI had initially examined the defendant's suitability for community supervision. Over time, the focus gradually broadened to encompass sentencing in general (an evolution also followed in probation practice around the world). After all, as one observer ex-

plains, what other court actor had related expertise, possessed the vantage point to observe the defendant in the community, and could provide a recommendation tied to neither the prosecution nor defense? Still, the development was not inevitable and could be viewed as surprisingly progressive. But a residual skepticism of probation's role continued among other actors—even a suspicion that the PSIs would tend to favor a probation sentence simply to keep the agency supplied with clients.

LOOKING AT YOU, BERNHARD AND MARK

Photo: SFO

DOP archives contain stacks of the agency's pre-sentence investigation reports dating back decades, including some PSIs associated with high-profile cases.

Above, the PSI of the 1984 subway shooter, a world-famous case meriting special handling of the paperwork. Charged with crimes ranging from several firearms offenses all the way up to attempted murder, nuclear engineer Bernhard Goetz was found not guilty by a jury of everything except carrying an unlicensed firearm.

DOP's report recommended probation, all but viewing him as a victim of the city's balllooning crime rate. The judge wasn't buying it. Two of the four victims were shot in the back—paralyzing one—and another was shot in the side. The investigating PO would probably have taken this into account if the official had simply paid attention to the most prominent columnist in the country, who had taken up the case big-time. The jurist sentenced the vigilante to a year in prison on the charge. He wound up serving eight months.

Three decades on, while sorting through old PSIs upon moving into her office, DOP's new government affairs liaison Katherine Spaulding suddenly began to hyperventilate. Her cheeks flushed crimson; her heart pounded like a sledgehammer. She had come across the PSI conducted in 1981 for the assassin of a lifelong hero of hers, a former Beatle. (Coincidentally, the recent work *Dreaming the Beatles* relates how back in the early sixties, a young IRS worker had opened an envelope to find the tax return of the Beatle's own hero, had begun to scream non-stop, and had lost her job.)

"Nobody paid any attention to the probation department unless someone screwed up. Then all hell broke loose."

The divided responsibility for sentencing defendants often gives rise to a certain tension between judge and probation officer. The pair sometimes take on the air of a long-married couple, although at least one twosome suggest a baseball battery. "I did most of my sentencing on Friday mornings," recalled a US circuit judge at the 1993 retirement dinner of Frank T. Waterson, who had served as the chief federal probation officer of the Northern District of New York. The judge continued,

> Waterson would come in just before the court session to review with me the pre-sentence reports furnished earlier in the week. These sessions were very bizarre, Kafkaesque you might say. I think he saw these sessions as some kind of baseball game

in which he was the pitcher and I was the catcher. I would say: 'I think I will sentence the defendant to two years, with three years' probation.' He would shake his head from side to side like pitchers do when they don't like the catcher's signal. I kept throwing out proposed sentences until he found one that he liked and then he nodded his head up and down, approving the pitch. He would then write the sentence down on a piece of paper and give it to me to read from the bench. Just in case I might forget.

He never had much confidence in judges.

Probation in Simon's state remains under the judiciary (unlike in New York, where it was transferred to the executive branch in 1974). The function handles a number of pre-sentence investigations. Yet he was astonished to hear that the PSIs in New York courts are conducted for those for whom probation would never be entertained, with the reports even including a recommended sentence. "When I started out, and was attending continuing education for judges," remarks the tall, balding former jurist, "I asked why wouldn't we want a pre-sentence investigation in every case. People looked at me like I was crazy. It was not the norm, and it was never the norm as far as I could tell."

For his part, Paul recalls that:

On the state side, there was no pre-sentence investigation whatsoever. If the judge asked for one, you ended up with basically a two-page report, limited to whatever the defendant told you. If the defendant said, I went to so-and-so high school—maybe you'd place a call to the school to find out whether or not he or she went there.

There was no real push for any mental health history or any medical history or medical records. They simply didn't have the resources or the time to do that.

We have a ton of cases—literally, several hundred cases per judge. And in some counties, you've got six or seven criminal sessions, so you're talking about a thousand cases at any given point in time. And there's no way any probation department in the county is going to keep up with that.

But Paul experienced it differently on the federal side, as a judge and previously as a defense attorney.

In every case, they did a pre-sentence probation report; whether it was a conviction or a plea, they would do a very thorough investigation of a living situation, education, employment, family situation, mental health issues, criminal record, and the like, and go out and interview people and come back with a very full report that would be given to the judge for review prior to sentencing. It morphed into an even fuller report because of the federal sentencing guidelines. And that's an area where we, as lawyers, try to have some input in getting that report written in a way that was helpful to our client.

Secondly, not revealed by the diagrams but essential to bear in mind all the same in any examination of the justice system, far fewer crimes wind up solved than the nation seems to believe. Law enforcement clears only six in ten known homicides, ranging down from violent to nonviolent offenses, and only

one in seven burglaries. Killers of Black Americans in the Los Angeles of the 1990s were convicted only a third of the time, while in 2018 Chicago less than one in five homicides were cleared—these rates reflecting police inaction in addition to the difficulties involved in catching the culprit in locales where cooperating witnesses could easily find themselves targeted or neighborhoods whose residents view law enforcement skeptically.

Such figures appear to buttress the case that lawbreaking remains a rational choice for some when observed through any quantitative assessment of risk.

But let's leave off with how things are supposed to work, with a prescient 2018 poem by a participant in DOP's Free Verse poetry program—suggesting all is not well in our land.

Broken America

I wish I knew how to heal
The growing rifts
Or even if they are healable,
I try and it feels as if I'm meddling
In something I shouldn't.
I'm still figuring it out,
hands through the dark.
I've been told to be quiet
When I want to scream
About the wounds
Of a country more worried about
Upgrades for the latest
IPhone or app.
Where are the repairs
To refurbish broken souls;
Not looking for
Medals, not looking for
Awards, just looking for
Reasons to keep being here.

SHERESE FRANCIS

From the brochure "Free Verse,"
Fall 2018

CHRISTOPHER

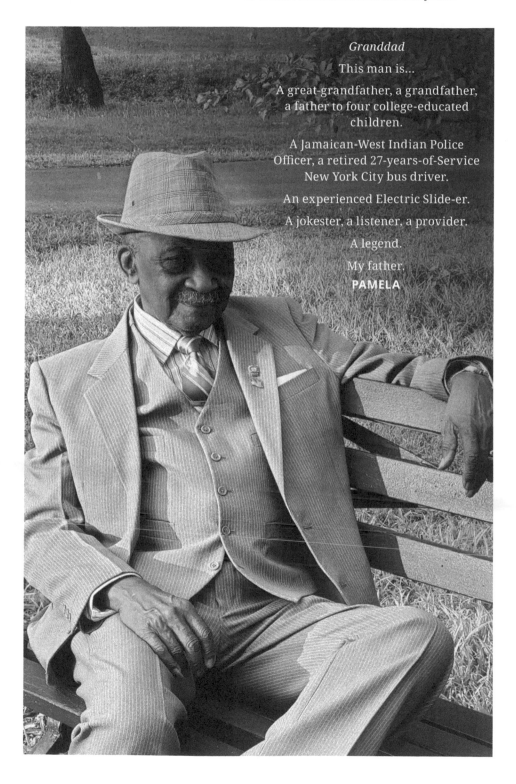

Granddad

This man is...

A great-grandfather, a grandfather, a father to four college-educated children.

A Jamaican-West Indian Police Officer, a retired 27-years-of-Service New York City bus driver.

An experienced Electric Slide-er.

A jokester, a listener, a provider.

A legend.

My father.
PAMELA

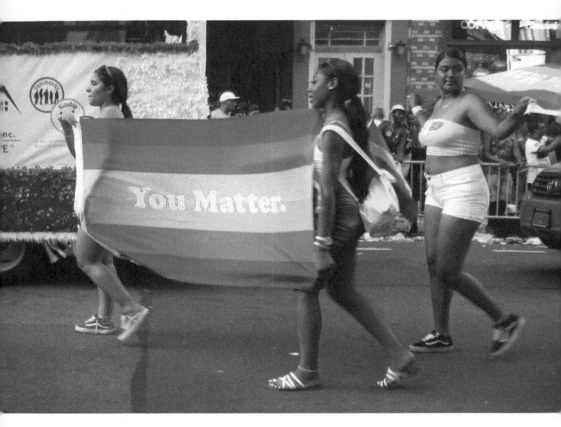

PATRICE

Outer beauty pleases the eye. Inner beauty captivates the heart.
NAPOLEAN

BRUCE

NICODEMUS

"COULD YOU HAVE DONE SOMETHING DIFFERENTLY?"

TEN
THE ROAD TO REFORM

Probation remained rehabilitative and steady state for a century after its institutionalization in Massachusetts in the late nineteenth century. But the American scene began to change, violently, during 1968–72, the onset of the twentieth-century crime wave—claimed by one observer to have triggered a half-century of counter-reform in criminal justice sanctions.

As we saw in Figure 2, while jail, prison, and parole volumes took off after a decade lag, none skyrocketed as much as probation. Rehabilitation left the building in favor of strict enforcement of a growing number of rules as agencies began to sink under rapidly expanding caseloads. This was true nowhere more so than the juvenile system in gang-ridden Los Angeles—its officers told to somehow supervise a thousand cases at a time. "Trail 'em, nail 'em, jail 'em" became the industry mantra. Some suggest only half-facetiously that those under the system's hyper-vigilant eye found themselves violated and reincarcerated for a sideways glance.

Ensconced in a corner office in the agency's bland headquarters high above Beaver Street off Bowling Green in Lower Manhattan, Jane Imbasciani—a top DOP official who began her career in 1986—recalls the era, her tone tinged with remorse. "We were competing

against each other to see who could send more people to jail in a day." Agency officials refer to this era as Old Probation.

And yet, compassion survived in cracks here and there throughout the haphazard national network of departments and agencies. A Kansas farm girl often accompanied her grandmother to her office in the Wichita probation department during the 1980s, as recalled in the former's 2019 memoir. The victim of domestic and other violence herself, Grandma Betty treated her clients with tough love, casting aside their excuses. "I just told 'em, hey, don't give me any bullshit about 'dysfunctional family,' honey—our family invented it."

"Through the frosted glass," the author recollects, "I'd hear the men talk about their struggles. Then I'd hear Grandma's voice— firm but tender, for all her big talk. I'd hear the men laugh and cry. When they walked out, they stood a little straighter, as though someone had treated them like human beings."

Only in the 1990s, after the crime wave abated, did some jurisdictions begin to walk back punitive practices. They formally experimented with a lighter touch, returning by fits and starts to probation's roots. New catchwords included "Evidence-Based Practices" and "Risk/Needs/Responsivity"—attempts to apply management techniques commonplace in other fields. Elsewhere, probation agencies stayed the course. Many in the South privatized the function to firms that did little besides assessing fees and jailing for non-payment. It wasn't until 2007—with over four million serving terms—that the number ensnared began to drop.

Meanwhile, by the second half of the '90s, New York City had embarked on a path that would soon make it the industry model. Probation volume shrank 56 percent from 1999 to 2016 because of the falling inflow associated with the crime reduction, as well as various probation reforms (including lighter sanctions than probation applied more often). These tellingly produced no uptick in reoffending.

With the agency's budget not shrinking in step with caseloads and low-risk individuals shunted off to kiosk reporting, more intense

supervision could be applied to those truly in need. The outcome proved so successful it led reformers to suggest as a best practice that agencies use a bit of sleight-of-hand to somehow hold onto their budgets while caseloads decline.

Even as the reins began to be relaxed for many, Imbasciani continued to face the risk of the type that had characterized probation from its beginnings. She couldn't watch the evening news on TV for fear of finding out what new offense one of her clients might have committed. One case sticks out.

"It was Christmastime. One of my clients shot up his pregnant girlfriend when she was out on the street trying to call from a public phone. Both she and her unborn child died. You wonder, could you have done something differently? You can't help feeling guilty. It was a very, very hard time." She looks off to the side for a moment to regain her composure.

All probation officers tread a narrow path between the Scylla of overly harsh treatment of a client and the Charybdis of failing to protect the community. But those serving a term often have it no easier, walking a tightrope with the calamity of incarceration awaiting below any false step.

Yet neither POs nor their charges can call on much sympathy from the other actors in the criminal justice process. The popular scorn of probation finds its corollary in the contempt shown by the police—who seem to regard it as law enforcement lite—and even (as we've heard from Paul) by the judiciary in certain jurisdictions and circumstances.

It was during 2011–2013, under pioneering DOP Commissioner Vincent Schiraldi, and with risks posed by new offenses once again under control, that DOP decentralized its operation into the most disadvantaged communities where most of its clients live. The agency co-located its Neighborhood Opportunity Network centers with other community service providers to enable one-stop shopping by agency clients. The department viewed the step as a kind

of correction for what it saw as the heavy-handed treatment meted out to these overwhelmingly Black and Hispanic populations by the rest of the criminal justice system. This new user-friendliness thereby came to be associated with the same city administration relentlessly promoting stop-and-frisk.

The NeONs have vastly helped client treatment. However, as Imbasciani recalls, considerable effort had to go into getting the communities on board. Only by offering resources to all community residents, and jettisoning DOP's punitive approach—which in the eyes of the communities had allied the agency with the NYPD they wanted no part of—did DOP ultimately win them over. And so one reform, decentralization, served as the catalyst for two others, a community-based service paradigm and rehabilitative practice. A cadre of representative stakeholders in each NeON center now officially helps run things. International observers cite the entire approach as a model for how probation can work.

Indeed, New York City practice represents the gold standard for a growing array of reformers hoping to turn probation into a more effective sanction while reserving its use for only those truly requiring supervision. They seek to reduce stipulations from two dozen or more to just a few, limit terms that may extend to ninety-nine years to only two, eliminate exorbitant fines and fees, and cease re-incarcerating for technical violations (which, all else being equal, reportedly penalizes Blacks up to twice as often as whites). Agencies should instead draw from a panoply of incentives (including early release) and punishments (such as GPS monitoring) to enforce compliance rather than simply tacking on more time. In short—brief, intense, rehabilitative terms.

Not all stakeholders find their position convincing. Even a NYC public defender has suggested that the main problem is people on probation who don't take it seriously until "the law hits them in the face." When Philadelphia's progressive DA, who would significantly reduce the city's probation volume, argued that failure-prone lengthy terms lead to more crime and less resident safety, a local judge laughed

outright. (Philly's rocketing homicide rate would soon enough embolden the DA's opponents to launch an impeachment.)

Still, addressing a probation violation by adding more time does seem counter-productive at best. No paternalism intended, but to reference the mode in which most Americans exercise punishment—that of parenting—this behavior by the criminal justice system resembles telling your unruly teen who slipped curfew that her or his grounding will only get more severe. Some other form of behavior modification needs to enter the equation in our child's best interests. Best to set aside any personal grievance about the apparent insult.

Meanwhile, both our former jurists endorse shortening probation sentences and limiting conditions. "I agree with a reasonable limit on the length of probation," Paul affirms. "I don't know the particular number, but somewhere between probably two and four years; beyond that, it really is diminishing returns. You're just going to screw it up and you're also using a valuable resource that others could use. If you have an improved effort of two to four years and are back in the community, then you're probably going to be okay."

As to stipulations, "Certainly from my experience, the fewer, the better. The more you impose, it looks good for society, it looks good in the newspapers, but your man is bound to fail. You just can't do it. It's too much to worry about, too much to be involved in. So if you can find two or three very hopefully positive and useful conditions—for example, drug evaluation and treatment is fine as long as there's a place to get drug treatment. If you're forced to look for places, that's going to fail. With mental health, I probably wouldn't do both. If you're going to have counseling, I'd look at the offense and decide which one would be more helpful." Drug addiction and mental illness impair many on probation—in New York City and across the country.

In 2018, reformers identified their Jean Valjean-like poster person in Philadelphia rapper Meek Mill. He had found himself like many oth-

ers endlessly spinning a hamster wheel for violations that presented no danger to the community—these adding more and more years to his probation sentence. Things reached a climax when the judge in effect sentenced Mill to two-to-four years in jail for, of all things, riding a dirt bike on only the back wheel down a New York City street. The NYC charge of reckless endangerment arising from the escapade would disappear on Mill staying in lane thereafter. Yet the Philadelphia judge had overridden the recommendations of both the local prosecutor and probation officer, and convicted Mill of the violation of having had any police contact at all while on probation.

The over-the-top sentence stirred international outrage.

In another celebrated case the same year, Julie Eldred of Massachusetts appealed to the state supreme court to avoid being incarcerated when she failed a drug test—a violation of her probation. Interested parties across the nation weighed in on this one.

One reader of a *New York Times* report was moved to comment, "We all do control 'small decisions' such as will I take this or rather that cigarette, but we cannot possibly 'decide' to get rid of negative emotions, so either we were lucky and got highly trained in self-care skills already during our childhood, or we weren't, and then substances may become the only way to keep your sanity." But the court ruled that rather than the unconstitutional jailing of an addict for relapsing, her penalty simply involved the revocation of her probation for a period, thereby exposing her to incarceration for her original offense of stealing jewelry to finance her fentanyl habit.

Violations also posed a problem for courts administering organization probation. After California's Pacific Gas & Electric (PG&E) utility caught a five-year term in 2017 for a faulty natural gas pipeline with a tendency to explode, the company proceeded to burn down an area four times the size of San Francisco in the most destructive wildfire in a century. An open-and-shut case of committing a new offense while on probation. "A corporation cannot go to prison," mused the supervising judge, a bit wistfully. No doubt aware of the

Rapper Meek Mill Sentenced to 2-4 Years in Prison for Violating Probation

Meek Mill Sentenced to 2-4 Years in Prison for Violating Probation

State's highest court rules that judges may force defendants with drug addiction to stay sober

Julie Eldred lost her case in the high court.

Mill case, he may have reasoned that if a two-to-four-year jail sentence follows from popping a wheelie while on probation, then a somewhat more serious punishment should at least be considered for setting the Golden State ablaze.

PG&E's failure to adhere to its probation terms, which subsequently contributed to even worse conflagrations, continued in 2021 to outrage and frustrate the judge, who began to consider extending the term or even resetting the five-year clock at zero. A former regulator, citing the 115 fatalities from the fires, observed that if the utility were a person, "they'd be looking at a death sentence." Undeterred, PG&E then set off another huge inferno.

Shortly before finally winning his freedom on a plea deal engineered by the Philadelphia DA in recognition of the dodginess of his original drug and gun convictions, Mill helped start up the Reform Alliance, a nonprofit that aims to improve community supervision for all. Meanwhile, a leader of Right on Crime—the conservative group that had kickstarted criminal justice reform back in 2007—also began to focus on probation. However, in a similar way to its monopolization within the correctional domain of both cultural references and spending, incarceration continued to suck up most of the reformist oxygen in the country's criminal justice system. It kept on doing so until policing became the dominant issue with 2020's national uprising.

"
THEY'RE NOT JUST THESE HARDCORE ORDERING-ABOUT TYPES."

ELEVEN
NEW YORK CITY PROBATION TODAY

A dog barked somewhere outside in the early Maryland dawn. The betrothed couple living in the Oxon Hill ranch house would survive the 1987 home invasion to tell the tale.

But the father of three confronted by the armed white man outside the Massachusetts doughnut shop in 1983 had not been as fortunate.

By September of 1988, the TV spot documenting the Oxon Hill case was ready. The Roslindale killing by the pardoned convict continued to be ignored by the operative, who had "Weekend Passes" placed on the air by an allied political group, neatly avoiding responsibility.

Before the media campaign concluded in October, the ad had been viewed by some eighty million Americans.

Beyond the election itself, the impact would be felt in the criminal justice system for a generation—right through the 2022 debate over bail reform.

And so we come to fully rehabilitative probation in New York City, two hundred miles to the northeast of Oxon Hill. A second chance

in the nation's capital of second chances. Another bite at the apple in the Big Apple.

DOP has instituted the menu of reforms urged by those seeking to walk the country back from mass probation. Perhaps most critically, a failure to obey technical rules no longer earns a violation at all. Moreover, as Imbasciani reports, "if a person gets re-arrested while on probation, we even wait to see what happens with that. If you get arrested for murder, you know that we're going to violate you, but there are some cases when you get rearrested, you can go to court for a long time and absolutely nothing happens. So we've learned not to file a violation until we know what's going on with that case." Meanwhile, a friendly advance warning to clients now heralds ostensibly "unannounced" home visits. A new normal for DOP. As Franze confirms, "They're not just these hardcore ordering-about types." Michael echoes, "It's a different flow now!"

Agency practices follow the general flowcharts displayed earlier: as in Figure 5, Adult Pre-Sentence Investigation and Supervision; as in Figure 6, Juvenile Intake, Investigation, and Supervision. Commissioner Bermúdez reports to the mayor of the City of New York.

The commissioner encourages her officers to employ Cognitive Behavioral Therapy to change hearts and minds. Bermúdez recognizes that the days of cookie-cutter solutions are gone forever; "one size fits one" is DOP's mantra, along with the "New Now," people no longer defined by their worst mistake. She doesn't just preach but also practices procedural justice, respectful of both staff and clients, while providing spaces that allow them to feel safe—mirroring what her agency has done for New York over the last two decades.

What is the best outcome of DOP's work, after all? Traditional measures of probation agency success and failure, such as re-ar-

rest rates, say more about law enforcement practices in the jurisdiction than the extent to which probation has worked. And so Bermúdez likes to point out that New York is the safest big city in the nation as well as the one with the lowest incarceration rate.

"We've not been recognized as an element of that narrative, but I think we're a huge part of it." As many as seven in ten complete their terms successfully.

If, in general, the probation function experiences its share of shocks—as we've heard from Imbasciani previously—there remain plenty of happy surprises among DOP clients. The commissioner is thrilled to relate one such in her executive conference room, where she was interviewed with her brain trust of Robert Eusebio and Lily Shapiro.

> Keshawn is Number One. NYPD advised me of its concern about four young people in the Bronx, so we began to focus on them. They had each been shot several times, had belonged to gangs, and so we launched an all-out blitz on them to ensure their and their community's safety. One of them pushed back. "You're telling me that if I need help, I should reach out to the police? Are you out of your mind?" Although he viewed us as out of touch with his reality, we tried to convince him that not all was lost. Yet he still resisted, leading some staff to throw up their hands, saying this won't work.
>
> But the case proved the power of not giving up on someone even though in conflict. We stuck with him to find a path out of violence.
>
> We eventually connected Keshawn to several opportunities. But mostly it was the power of the relationship with his probation officer. He ended up

able to get employed, finding a way to give back to younger kids in the community. He still had a lot of demons to face but he stopped being involved in certain unhelpful activities. He finished his probation without getting re-arrested and spoke at his graduation assembly. His probation officer cried.

Keshawn was somebody who was sure his days were numbered. "How can you tell me I will be alive next week?" Anger, hopelessness—it was super sad. And he's a super-smart kid, but so disconnected. When we talked to him about pursuing his education, he countered, "I don't need to go to school—I got Siri."

The Commissioner remains shocked at the level at which we have failed some young people educationally.

Inspiring as many find her, Bermúdez is hardly a one-woman show. DOP benefits from the talents of others who put up with the low pay and lower prestige of the function to save so many—who go far beyond helping clients color between the lines. There's Catrina Prioleau at headquarters near Bowling Green, who oversees the NeON franchisees and is known and welcomed in every NeON service area. Yvette Rivera offers a kind word to all she encounters in the somber Criminal Court building, trying to ignore the screams of inmates from the elevator hurtling past her floor on the way back to lockup. Yvonne Rodriguez, in the more modern juvenile section nearby, wonders if she'll find any client she meets today more depressing than the youth who, after helping a blind soul pay his transit fare, walked off with the man's wallet. Pedro Luncheon, up in a Bronx court furnished in early Scandinavian, coaches a new judge in collecting delinquent fines from a huge variety of those

on probation with an even larger variety of rationales. Stephen Cacace puts some clients to work on community service, cleaning grimy East New York sidewalks of graffiti. Jocelyn Jordan, in a Kew Gardens warren of intake offices, brings into Queens probation a counterfeiter, a type of felon associated more with the 1930s than today. And Marla Morrissey, in a low-ceilinged courtroom nearby, aids a judge in holding probation violators to a 100 percent standard of compliance for the first time in their lives—maybe a first for everyone.

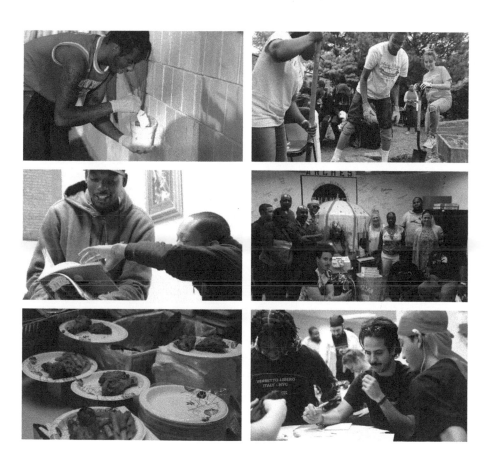

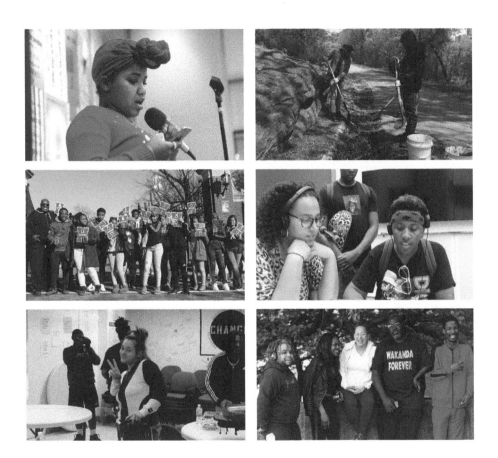

SO YOU WANT TO BE ON PROBATION: A FRIENDLY GUIDE

It sure beats prison. And so a lively, savvy PO working out of DOP's Brooklyn Adult Operations will be happy to oblige. Let's call her PO Vito, as her vibe resembles that of *My Cousin Vinny*'s dynamic Gotham heroine.

As a high-risk client who has been imprisoned for a previous offense, you'll meet with her your first day. In the drab Adams Street office, you encounter a penetrating once-over. "My goal," she will inform you, "is to transition you down to an officer handling medium-risk clients, and then to one for low-risk individuals, leading to an early dismissal. Let's see if we can get there!" So your goal, apparently, is to escape her clutches.

And that's it for today. Vito has taken the commissioner's advice on procedural justice to heart, not challenging you or quizzing you on semiotics at the first meeting but building a relationship with you over a few weeks first—including a home visit.

No worries, you won't have to feed her; when you hear the rap on your door, you'll see that she's left all but one of her posse behind.

In about a month, the two of you now on familiar terms, the PO's strategy becomes clear. "Assess yourself first of all," she'll instruct you at your fourth meeting. "What are your strengths? What are your weaknesses? And let's put your record aside. There's always two people, the one in front of me and the one I read about. Let's look at the real you."

Is this the Motivational Interviewing you sneaked a peek at before coming here? You'll be, like, "this should be fun."

And so you start to reflect on your life, a smile beginning to take shape at the edges of your mouth. Or maybe you're one of those who struggle with the task. Vito will remind you how you got your chiropractor license while incarcerated. Didn't that take effort? Wasn't that a major accomplishment?

If you don't want to write—maybe you've got handwriting or literacy issues—no big deal. Just talk to her.

Then it's time for your weaknesses. "And yes, even your illegal activities."

Now you'll wonder where this is going.

She'll sense your hesitancy. "I already know what you've been arrested for," Vito will remind you. You jot a few things down. "Why are you continuously falling into this cycle? What would you like to change?" You consider this and offer a response. "Well, these are your risk factors," she replies. "They can be a strength or a weakness. They can make you or break you." She'll tell you about herself as an example, how she was raised, how her thoughts and beliefs may have gotten her into trouble—and for that cycle to stop, she needed to change. So, she has felt some of the same things as you.

This may strike you as too much information but continue to look interested.

"Here's what we are going to work on while you are on probation. We will combine that with everything else from our conversations and your criminal history. We'll join all that together and create a nice goal for you." Sounds peachy.

You'll soon find yourself sharing secrets with Vito that you may have never told anyone except your pet boa constrictor. The interview goes on. And on. She'll ask about your drug and alcohol use, your parents, your friends, whether anyone knows you're on probation, if anyone you know has been in trouble with the law, how you felt when she showed up at your door, what your neighbors may have thought, whether your patients know you're on probation, and if you can take time off from work to report to her.

"What does your family like to do? You and your wife and children, for leisure?"

You'll start babbling, "I think we're going to Florida for winter break next month! Orlando. The kids are a bit old

for Disney World, but there's Universal Studios. Sea World."

Then it comes. "I would hate to put a burden on you while you're on probation. Leaving the state is a privilege. And it's a decision made by your officer—myself—consulting with the supervisor and the branch chief. It's something that we would sit down and discuss. But for the first six months, there's no movement out of the state. You need to prove yourself first."

You had guessed that probation would be like summer camp but seem to have misjudged things. Suddenly your mind is elsewhere, imagining the family scene that evening. Some guys' wives will put up with anything. This?

The PO will share hard-luck stories of promising young men whose lives were ruined by missteps, now trying to return to the straight and narrow.

"But then you have the opposite ones, the professionals. They tell you, 'Once I'm out of probation, I'm going right back.' I've had those too.

"And I'm, like, 'Are you kidding me?'

"'This is nothing,' they'll reply.

"'Do you understand that your next stop is prison?'

"'It's not a problem.'"

Say what?

Vito knows you're not like that. "I think you're ready to change. You're going to get used to it. Three years seems like a long term—but it will go by quickly, even if it's going to be very intrusive at times."

Okay, she's got you now. Enough foolishness. You're lucky you were put on probation. Fortunate to have someone like PO Vito on your case. You ain't her first rodeo—not by a long shot.

"It could feel like you have a second wife," she concludes, then catches herself. "But you have a daughter, and daughters like to keep tabs on you as well. So, it will be like having a third person in your life, interfering at all times." Her green eyes twinkle.

Let's get this party started.

*The Health & Harmony annual event is one of many opportunities proba-
tion officers have for giving out brochures with info for health programs
in local organizations to help the community unite.*
HENRY

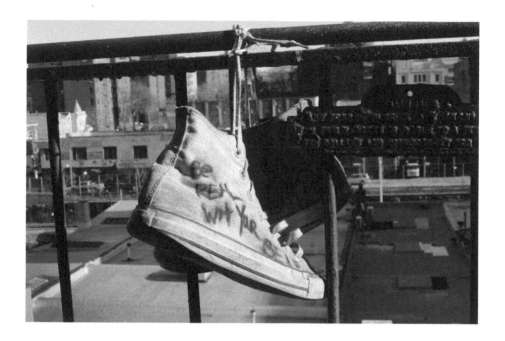

*No matter how far beyond life may take you, no one can take a mile in
your shoes. Where I come from, our neighborhood doesn't come from
seeing doctors and lawyers. I come from drug dealers, gang bangers,
robbers. To have the right role model, it gives us an opportunity to have
support by our communities and elders. These are the miles that stood
out to me when you have sight for hope.*
EMILY

Even after the biggest storm, at the end the sun will always shine.
ANDREW

Probation officers observe the client's broken apartment door prior to knocking.
HENRY

"Tell me what happened."

Opening up to your probation officer is not easy at all. Especially when you're already being labeled a criminal.

When you do finally build a bond and come to an understanding with your PO, suddenly without your permission you're given a new one.
HENRY

A beautiful garden filled with mysteries to explore. My love of photography has enabled me to express my thoughts, feelings, setbacks and rejections I encountered during my childhood to adulthood as an individual. Diagnosed with autism.

With the continued assistance of a supportive network, I will solve the mystery to my life.

VERNEL

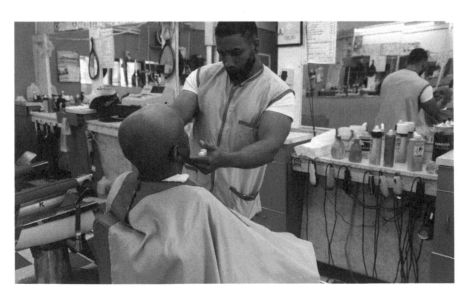

CARL

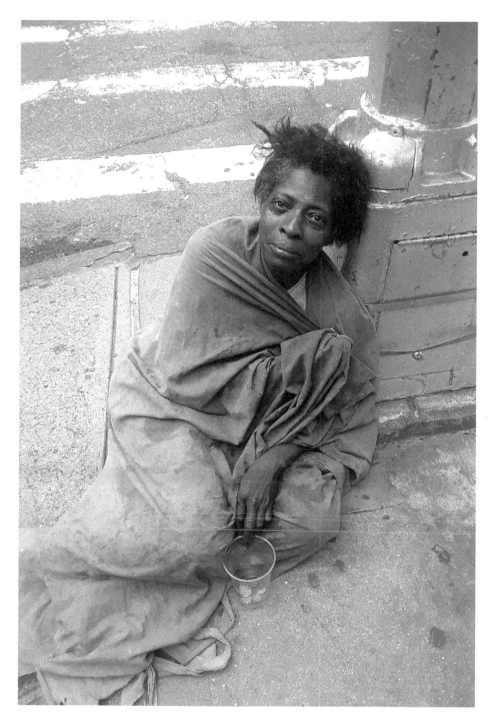

Homeless but not helpless.
CARL

CAITLIN

To be seen yet unseen

Threatened by my mere appearance and identity

Looking upward and onward

There are two sides

Seeking hopefulness and strength

Stripes

On the flag and on my headscarf

Mimicking each other

Trying to find a balance

PATRICE

Empty your pockets, walk through the metal detector, and hold your arms out so I can scan you with this metal detection wand. Now turn around so I can scan you from the back.

Grab your things, sign in, and have a seat until your probation officer calls your name.

HENRY

I see the tears you cry and without being told to do so, I comfort you with a kiss. I don't need words because you don't have any. I understand. "Don't worry, I will take care of you, Soleil."

ALISHA

DYLAN

CARL

The majority of the inmates on Riker's Island haven't even been convicted yet.
HENRY

*I'm a diehard New York Yankees fan and the team has always
held a meaningful place in my family life.*
VINCENT

So many end up going back to jail because of technical violations.
HENRY

Ever been evicted? Do you know what it's like to live somewhere all your life and then one day someone tells you that you have thirty days to move?

This is one of the many problems people have that probation officers have assisted with.

HENRY

NICODEMUS

PO George meets with her client to inform him of NeON Arts program opportunities.

HENRY

Some probationers check in monthly using a kiosk.

MOSHELLE

Probation officers pay a home visit to a client after someone broke into his apartment, to ensure he is okay and doing the right thing.
HENRY

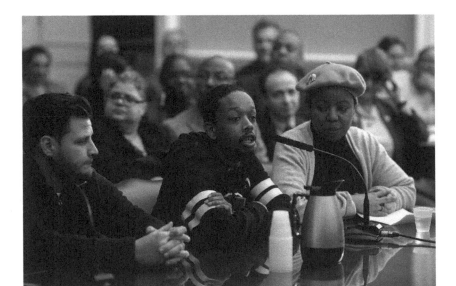

Dylan shares that he was once a mentee but has since become a mentor.
KALEFE

There's a lot of emotions that go into visiting a family member or friend on Riker's Island. Getting up early enough to get there during visitation hours. The commute, a bus or train to the Riker's Island bus. The searching process—OMG! They search you, your bags, your pockets, your clothing—and your children get searched. Strip-searched! Females have to remove their metal-wired bra. On top of that, you have to stand still in line with other visitors, facing forward, while the police K-9 dog comes around and smells everything and everyone, including the children and babies. Traumatizing! Especially if your child is afraid of dogs.

HENRY

"WE TRULY HAVE MADE MAGIC TOGETHER TONIGHT!"

TWELVE
REFRAMED

On the evening of October 3, 2018, an exhibit staged by Seeing for Ourselves of the best photography to date opened in the spacious, white-walled Brooklyn waterfront bookstore of publisher power-House. The vibe was electric, adding a touch more glamor for a few hours to an already hip neighborhood. Photographers basked in the limelight, with local media covering the event. News12 Brooklyn commented on one photo, "This isn't just a graduate, it's a mother's sacrifice"; said about another, "This isn't just a homeless person. It's a connection to family." The reporter summed it up as "Seeing the world—and themselves—in a whole new way."

"To Brooklyn now, where a new photo exhibit focuses on the work of people who have overcome personal struggles."

Christopher's parting words of wisdom to the crowd attending the opening: "Don't be afraid to shoot." A pause. "And I mean the camera," bringing the house down.

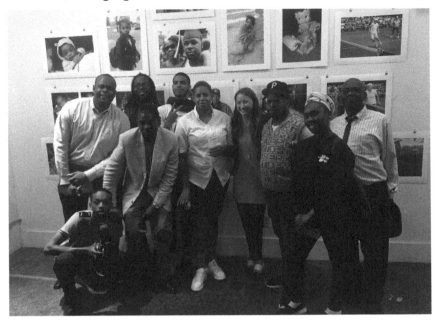

Photographers and teacher at the Arena. Photo: SFO

The bookstore showcasing of work from the first round would be followed by a March 2019 exhibit in Hunter University's rectangular East Harlem Gallery displaying second round highlights. If anything, the excitement at the March 8 opening exceeded the Brooklyn show, with Nathalie telling the exhilarated crowd, "We truly have made magic together tonight."

The stage was set for a third and yet even higher-voltage exhibit in September—this time in the center of the city's gallery life, the Chelsea section of Manhattan. The high-end Denise Bibro Fine Art space, nooks and crannies adorning a large central room, provided the setting. Another show covered by local media. It would be followed by a fourth in the same gallery in March 2020 that, it would turn out, no one was able to attend in person.

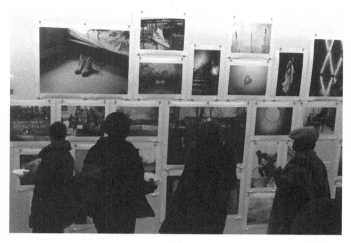

Viewing the work in East Harlem.
Photo: SFO

Photographers, guests, and teacher.
Photo: SFO

The entire photography initiative began to take on the air of the paradigmatic Hero's Journey. Overcoming some initial reluctance, then equipped and trained by a nonprofit's so-called "magical helper" aided behind the scenes by her SFO colleagues, and kept on the path by neighborly allies, those on probation who undertook this mission had returned with brand-new imagery to help reset probation's reputation—and so hopefully aid in undoing mass incarceration itself.

September 5, 2019: Formerly homeless, Moshelle (C) thrills the Denise Bibro Fine Art gallery crowd with news of her new job and apartment. As she told News12 Bronx TV, "Probation—which I thought was going to be a death sentence for my career—in so many ways ended up saving my life."

Photo: SFO

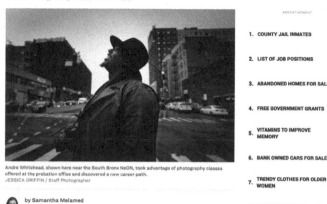

January 10, 2020: *The enterprise even began to attract the attention of the out-of-town press. The media depiction of probation had begun to change.*

January 27, 2020: WABC-TV.

The news show host tells DOP Assistant Commissioner Rodney Levy and Andre: "This program really is changing lives—and hopefully helping to change the criminal justice system."

EXHIBITIONS

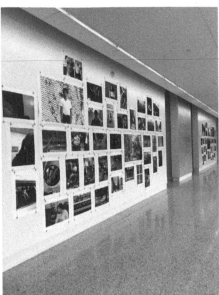

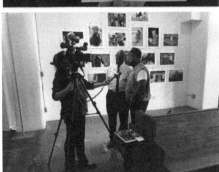

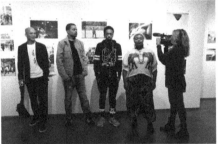

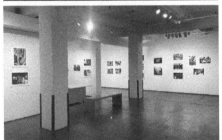

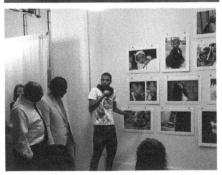

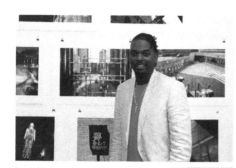

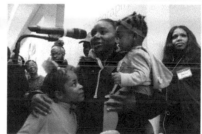

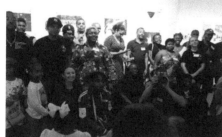

New Visions:
Activism Through the Lens

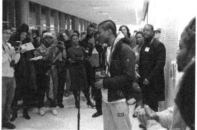

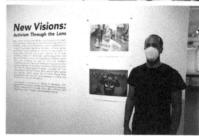

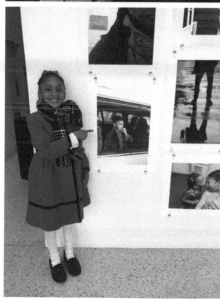

"ON PROBATION YOU CARRY YOUR PRISON WITH YOU."

THIRTEEN
STAKES

So what happens if nothing is done? Or if this effort fails to accomplish its aims?

What if the states that haven't yet undertaken reforms of probation continue to sentence all those convicted but not incarcerated to lengthy terms with lengthy stipulations to obey, including high fees? If this is the case, the sanction will continue to represent a stepping-stone on the way to incarceration—as if we need more of that.

Then probation will remain the poor stepchild of the criminal justice system. In a way, it will have blown its second chance.

We Americans deserve better. After all, we invented this practice—which continues, even now, to spread across the globe. And beyond food, clothing, and shelter; beyond security, reproduction, and sex, justice may be our strongest need.

When any public service—from housing (as we saw in *Project Lives*) to mass transportation to criminal justice—performs poorly, consequences extend far beyond the immediate damage. The very idea of government as an effective servant of its citizens

weakens perceptibly. One observer has noted that mass incarceration itself got a lift when the failures of the welfare state in the 1970s helped persuade the government to offer crime protection to its citizens instead. The disconnect between flat incarceration rates and rising crime had led to a popular backlash that the government ignored at its peril.

Meanwhile, even in New York City—the industry model—the personal stakes for those on probation remain high, with the consequences of falling off the tightrope bordering on the almost unendurable, given the state of American lockups and the associated threat of a life damaged beyond repair. The reality is that there is so little done there to prepare prisoners for eventual release. Paradoxically, the disrespect accorded probation in our country in part seems to stem from the view that the bullet those under community supervision have dodged is so much worse. The published observation that modern America remains the only society in world history where men find themselves raped more frequently than women remains debatable, but policy analysts cite our failure to protect those we jail and imprison as a moral catastrophe and ultimately a danger to the community. As a criminologist interviewed on the podcast *Honestly* put it in 2022, residents of high-crime areas have seen this movie and now want something different from law enforcement. Incarceration breaks up families, undermines neighborhoods, destroys wealth. Compared to a prison sentence, a term on probation is akin to winning the lottery. But each encourages a misplaced sense of superiority, guilt, or both, in those of us avoiding such a fate. And as we've heard from Moshelle, probation as well as prison often follow from plea deals that entrap the innocent along with the guilty. When we evaluate prosecutors by their conviction rate, this should not come as a surprise.

Even in New York City, the experience of supervision within the community burdens its clients while intending to help them. As SFO's

European counterpart has emphasized in the photographs by its own participants, it's no picnic to live your life under constant observation, at constant risk, under constant constraints, and constantly reporting in. As a NeON photographer observed, when interviewed in the Hunter East Harlem Gallery festooned with his work and that of his colleagues, "On probation you carry your prison with you."

Elsewhere than NYC, the downside may outweigh any benefit—even when compared with incarceration, as not just a few have opted for instead.

You've known since you were a toddler that if you commit a crime, you will go to prison, and there's no question that prison guards and wardens come with the territory. But you only find out about probation when you get it. Then the disconnect between remaining at large in your community yet living underneath the watchful eye of an officer armed with two dozen do's and don'ts can seem an alternate inhospitable universe. Bizarre. Unfair. Infantilizing. The opposite of what some may feel they need.

A broken criminal justice system can leave its victims unable to chart any path forward. Shocked no matter which way they turn, like animals in a lab experiment, they wind up neurotically aggressive and depressed. Unfairness is one thing, but the system seems so irrational at times that the conspiracy-minded see intentional design behind the craziness. The illogic not a bug but a feature.

Moreover, if various factors predispose many to offending, almost anyone can find themselves ensnared given the right circumstances. Eight in ten males will have significant police contact sometime in their life. As the 2018 paper *Measuring Change: From Rates of Recidivism to Markers of Desistance* put it, "In youth, crime is so statistically prevalent that it is considered sociologically normative, particularly among males—a fact that explains why most crimes are committed by men between the ages of 15 and 25."

And so we come to the third decade of the twenty-first century—when the nation paused as crime escalated, after beginning to walk back mass incarceration a few years earlier. Even as reform was enacted in 2018, the forty-fifth president and other politicians had nervously looked back some three decades to a presidential election campaign hinging on the consequences a year earlier of an act of mercy offered to a lifer in a Massachusetts prison. The convict took advantage of a hugely successful if indifferently managed weekend furlough program—which had saved lives overall—to have his way with a Maryland couple. The living nightmare of certain white Americans, oblivious to the trauma of countless Black women whom slave-owners had had their way with over the centuries, played to the hilt against the Bay State governor.

The cynical use made of the home invasion during the 1988 presidential campaign would, in the view of one of probation's more prominent reformers, keep the practice punitive for many years afterward. Small wonder that it was the operative publicizing the case who would be pilloried by a US congresswoman as "probably the most evil man in America." Small wonder as well that the evil that men do live on long after them.

The iconic TV spot deciding a presidential election and the specter haunting American criminal justice reform ever since: Willie Horton, 1988.

These may be the stakes, then, when a couple of hundred determined New Yorkers set out in their community each week with their cameras.

KALEFE

VICTORIO

The eye-catcher.
NICODEMUS

VICTORIO

KALEFE

NYC is all about the hustle. However, it can be a place where unusual, funny things can appear just about any place. You just have to keep your eyes open.
VICTORIO

DYLAN

KALEFE

NYPD Officers guard a subway turnstile to prevent fare evasion.
HENRY

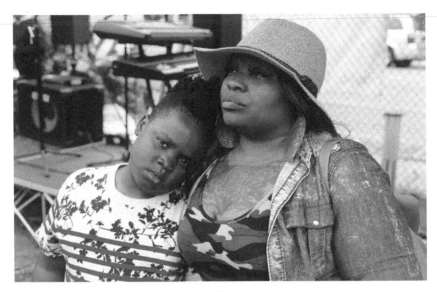

RHAM

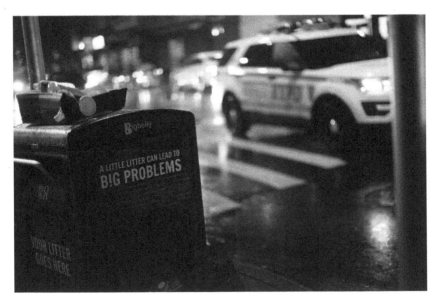

KALEFE

*I stumbled upon a dream of steel and concrete. Rays of light dance,
bowing for their applause, roses were tossed into the deep gray to feed the
dying imaginations of man. A beautiful child was built, assigned his
punishment with the giving of his name. To be judged by men would be his
fate. Forced to spend half his life within a cage, but no matter how
bleak the situation had seemed, this child kept a fierce smile on his face.
When questioned by his oppressor, of the state of his unbroken spirit,
the child simply asked, do you not see the light?*

LKM/WOLFPOET

LEO

"

YOU COULD PICK UP A CAMERA AND SHOOT SOME PICTURES."

FOURTEEN
ANSWERS

The questions remain.

Will probation continue almost as an afterthought in the American system of justice?

Can we put an end to people endlessly pinballing between community supervision and lockup, with probation serving as a staging area for incarceration or even its promoter rather than a clear route away from involvement with the justice system?

The answers lie mostly in places other than New York City. They lie in the ability of probation agencies across the country to demonstrate how they work better than jails and prisons to keep us safe while treating their clients humanely. In many states, this means taking their practice up a notch or two, while everywhere agencies need to develop the analytics to compare results of these differing responses to criminal behavior.

For all the anecdotal evidence, and gut belief by practitioners (and Seeing for Ourselves) in the relative efficacy of probation, it sadly remains unproven in the eyes of both criminologists and the American public that the sanction leads to less recidivism

than incarceration—ironic, as it was this very proof by its founder John Augustus that led to probation's acceptance by Massachusetts in the first place. Or more desistance from criminal behavior, a metric favored by reformers. Or better societal outcomes such as safer environments. Demonstrating probation's efficacy along each of these axes, along with returning to its rehabilitative roots, can help build popular support for massive change.

What SFO seeks, and what in its humble opinion justice demands, confronts the challenge of moving parts. First, mass incarceration must be reversed, with many of its current and future clients shifted to probation, diversion out of the criminal justice system (e.g., to a drug or mental health treatment program), or release. Second, mass probation itself must lessen, despite a massive inflow of those currently or potentially incarcerated, which would otherwise overwhelm the function. This requires an even greater, synchronous shift back to diversion or release of a good portion of the three million now on probation, along with so many more in the future. If crime rates can once again be brought under control, an equilibrium can be achieved at substantially lower levels in each sanction.

As with so many reforms, improved financial resources remain a key enabler. The news in this case is good. The opposition of vested interests aside, decarceration will free up billions, leaving funding available to not only accomplish this shifting of gears but allow for more intensive supervision of the higher-risk individuals who will come to constitute a far larger share of probation's clientele. Yet the task proposed remains monumental.

While the probation reform movement has the wind at its back, it still lacks the popular appeal of prison reform. Even for absurdly lengthy periods and even involving the actually innocent, probation lacks the universally appreciated drama of incarceration. And so much spadework remains to be done.

But with an ounce of crime prevention worth a pound of probation, what can we do to encourage lawfulness from the get-go?

It will surprise few that SFO comes away from this project convinced that the answer in part lies in a repair of the safety net. While ostensibly a progressive measure, conservatives could applaud the consequent rise in equality if it allows individuals to be finally held fully responsible for their behavior—a traditional right-wing aim. But one and all need to recognize that each of us might break the law were this the only option for feeding our family. It should not come to this.

And the answer also lies in the (preferably voluntary) effective disarmament of the population, which we believe will encourage less aggressive law enforcement for whites and people of color alike. The four hundred million firearms in our country seem three hundred ninety-nine million too many. When some have guns, others find themselves forced to obtain one. As a participant observes, "If you're raised in an environment where you really need a gun, the streets heavy, you're going to keep it. I guess I felt real vulnerable." And as for hunting, the president who had famously rescued his PT-109 crew in the second world war observed, "That will never be a sport until they give the deer a gun." The time will hopefully come when going about armed will have lost its allure in inner-city precincts and rural counties alike. (Imposing fees and liability insurance requirements on gun ownership as in San Jose may prove helpful in more ways than one.) As photographer Taquan tells his own students in the Bed-Stuy center, "You could pick up a camera and shoot some pictures. You don't have to pick up a gun and shoot somebody." Interpret your environment rather than seek to dominate it.

Whether we're a conservative farmer in the Midwest or a liberal professor on the East Coast, a beautician afraid for her opioid-addicted teens down south or a teacher out west trying as a single mother to make ends meet, all of us sense that our system of justice needs a reboot—particularly if we are Black Americans, as the nation came to recognize in 2020. And in our heart of hearts,

we may feel the same about our country, which for all its goodness many perceive has lost its way and must somehow find redemption. Beyond those facing incarceration, beyond probation itself, America may need a reboot. A second chance.

We as a people may need to relearn how to color between the lines. And to see the world—and ourselves—in a whole new way.

But we got this.

It was, after all, no accident that the second chance known as probation arose in America, the last best hope of Earth. The COVID-19 pandemic has already provided a model for less obtrusive community supervision amid an influx of those prison-bound, along with the freeing of many incarcerated for noncriminal behavior like missing a probation appointment, imbibing alcohol, or traveling without permission. Major reforms were enacted in 2020 in California; the following year, in Georgia—long one of the most punitive jurisdictions—and Virginia; and in 2022, in Florida. Meanwhile, Massachusetts in 2022 joined California and Oregon in abolishing probation fees.

For its part, New York City's probation function continues as the apparent national pacesetter, with its new mayor elected in 2021 on a platform of combatting crime an ardent supporter of DOP's NeON programming. Even amid a national crime explosion—and scathing media portrayals of the city's own crime spurt, which helped tip the House to the GOP in the 2022 midterms—New York has remained one of the safest big cities in America as well as one of the least incarcerated. As Ana Bermúdez points out, DOP has "not been recognized as an element of that narrative, but I think we're a huge part of it." We think so too.

In a Whole New Way aims to give her clients who participated in this project—standing in for three million others across the country—control over their image, and a voice.

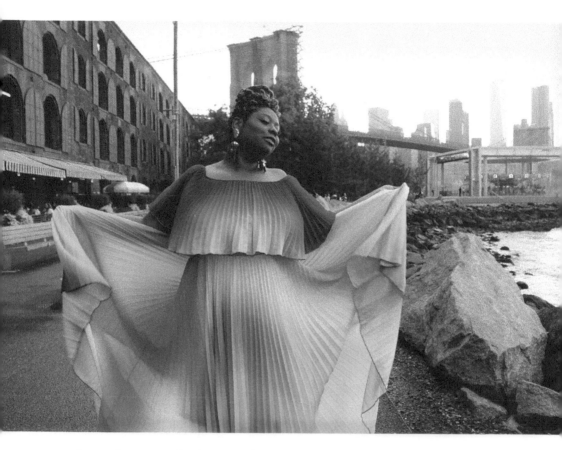

Our style, our aesthetic, our individuality ... belongs to us and we must continue to shape and embrace it. As we make waves in mainstream society, we also must remember our history and those who have paved the way for us to effectively move forward.
PATRICE

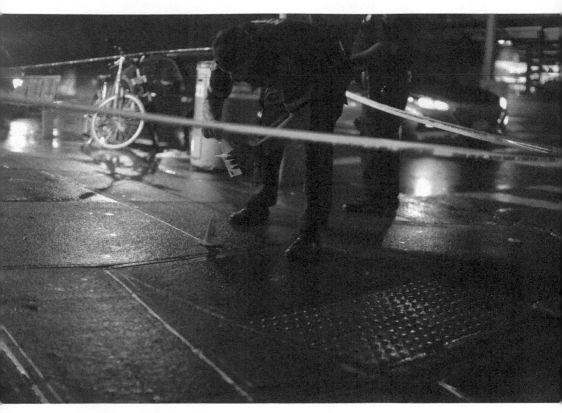

KALEFE

CARL

Trotting through the sand.
ZAHRA

Our happiness keeps her sweet. The trials kept her strong. Her sorrows only showed she's human. Failure kept her humble. Success has her glowing. Our family keeps her going.
ELSA

MEGAN

TATIANA

CARL

YAW

A picture tells a thousand words.
DEVON

GREG

MOSHELLE

VERNEL

So much happiness being displayed, in an event where people were coming together. A little girl was showing her dance skills and people were encouraging her to keep going.

VERNEL

CAITLIN

There is an old tuberculosis ward I visit to remember the people who passed in this garden of grieving. Not many people know about this. A place of forgotten people who suffered.

GREG

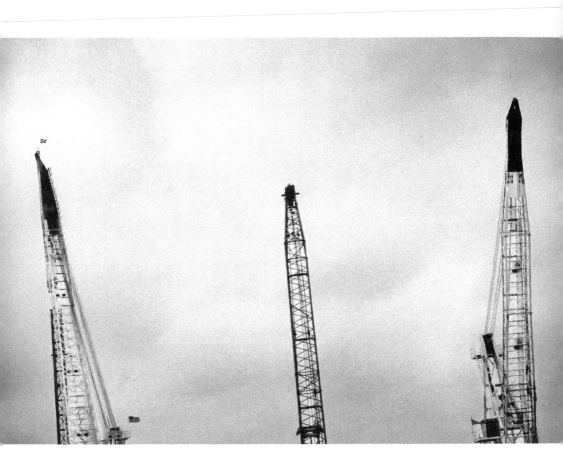

A new beginning. No matter when you see a crane, it's always something starting from the beginning. You don't know what it is, but at the end of the day you always know that there's something new that's about to start. Every time I see a crane, I have to take a picture.
CHRISTOPHER

ACKNOWLEDGMENTS

The seeds of *In a Whole New Way* were sown by the favorable reception of *Project Lives* in the spring of 2015. Our first book, on behalf of New York residents of public housing, had catapulted Seeing for Ourselves to prominence among participatory photography practitioners worldwide. All of us in this field equip and train marginalized populations to take charge of their own public narrative by documenting their lives photographically. The practice turns traditional photojournalism inside out. The camera is turned over to those customarily on the other side of the lens, with the subject becoming the storyteller.

The product of a four-year effort in the public housing of New York City, *Project Lives* represented a new art form and a new style of advocacy. The book memorialized a unique effort to teach and equip residents to capture, share, and preserve their own stories with photography.

In the summer of 2015, the Mayor's Fund to Advance New York City pointed us toward the Department of Probation for a new temporary home.

By January 2018, with a grant from the National Endowment for the Arts (NEA) in hand—thanks to the endorsement of US Sena-

tor Kirsten Gillibrand of New York—we were underway, now embedded at DOP. The Works Progress Program (WPP) and NYC Opportunity at the NYC mayor's office, along with the Young Men's Initiative, undertook to pay participants modest stipends in keeping with the city's interest in promoting both work readiness and specific skill attainment.

So many people have helped this project that it could almost take a chapter to name them all. These have included our freelance editors James Attlee, Amanda Barnett, K.J. Wetherholt, Lisa Kaufman, and Stephen Power, as well as DOP staff—especially Chelsea Davis, Lily Shapiro, Catrina Prioleau, Robert Eusebio, and Michael Forte—but also Jane Imbasciani, Yvette Brownridge, George Goodmon, Yvette Rivera, Joan Gardner, Yvonne Hernandez, Tim Salyer, Pedro Luncheon, Karen Armstrong, Vincent Carrique, Stephen Cacace, Marjorie Fisher, Tracy Dancy, Jocelyn Jordan, Douglas Wong, Marla Morrissey, Sharon Schinnery, Tyra Grant, Yahaira Castillo, Melissa Martinez, and John Corrigan. Heartfelt thanks also go out to Commissioner Ana Bermúdez, who after all took the biggest chance on our success. Meanwhile, former Commissioner Vincent Schiraldi developed many of the DOP innovations celebrated in this volume.

Nevertheless, the views in this book are our own, reflecting the opinions and/or positions of none of the above.

Anyone like us embarking on a path toward strengthening probation stands on the shoulders of others, including the organizations EXiT, Reform Alliance, Arnold Ventures, Pew Charitable Trusts, The Marshall Project, the Vera Institute of Justice, The Council of State Governments Justice Center, the National Institute for Criminal Justice Reform, the Criminal Justice Policy Foundation, the National Center for Juvenile Justice, the American Civil Liberties Union, the Ford Foundation, Avenues for Justice, the Alliance for Safety and Justice, Right on Crime, and The Crime and Justice Institute. And anyone like us practicing participatory pho-

tography (also known as photovoice) owes a debt to American aid workers in rural China, themselves building on a tradition of documentary photography stretching back to Jacob Riis.

Jeanee Layman—encountered at the Loudon Arts Film Festival in 2021—became the film's first huge fan, continually finding new ways to amplify its message. Steve Woolworth of the International Community Justice Association (ICJA) provided early invaluable support of the film, while Linda Connelly of ICJA and Successful Reentry became a key supporter of both the film and book. And then Veronica Cunningham of the American Probation and Parole Association (APPA) took it a step further by hosting a workshop on the film at APPA's 2022 annual conference in Chicago and planning a plenary session on the film at the 2023 annual conference in New York City.

Elizabeth Glazer of the nonprofit Vital City (who got to know of the film via Lisa Melmed, who in turn found it through the invaluable documentary support service, Show&Tell) began to pull together a symposium on the film to tie in with the publication of this book in June 2023, raising the profile of this reform effort further yet.

It was an honor to screen the film as 2023 got underway for NYC Deputy Mayor Philip Banks III, who sent word about it to the entire City Council. It was similarly gratifying to receive a pat on the back for the film from Arthur Jones of the Maine legislative commission on parole reform. Thanks are also due to Angee Simmons and Bob Petts of NETA (the PBS gatekeeper) and station relations manager Alexis Bushell for their belief in the film.

Two retired judges have shared their experiences and insights for the book—selfless contributions as we preserve their anonymity, not even indicating in what part of the country they served. Like Jacqueline Engstrom, they provided an invaluable service by wading through the first draft.

Our main grant support has been provided by Meg Brennan of the NEA.

TV, stage, and screen actor Richard Hughes has been an invaluable ally in our corner, dating back to our joint work on Agent Orange relief in the aughts with his nonprofit Loose Cannons. Others involved in such work who have supported the current effort include Thi Bay Miradoli. Prominent Chelsea New York gallery owner Denise Bibro staged inspiring shows of the photographers' work in 2019 and 2020—as well as working with George to mount both the participatory photography exhibit *Unbroken* in 2004 and a show of the works of celebrated Magnum photographer Philip Jones Griffiths in 2005; meanwhile, thanks go to the staff of the Islip Arts Council for agreeing to mount an exhibit in 2023. Master printer Holly Gordon produced stunning large-scale photographs for the various exhibits of the work, having provided similar services on *Project Lives*. Andy Ryer, Kevin Goody, and the staff of Thomas Memorial Library in Cape Elizabeth, Maine staged a thrilling exhibit in 2022, along with hosting a remote film screening and panel discussion including local justice officials. Christoph Gelfand of Portland, Maine's True Life Media added infinite magic to the film as its editor. And David Wilk found a good home for the book at Prospecta Press, so ably copy edited by Jeremy Townsend and designed by Alexia Garaventa.

Of course, we salute those clients of DOP who participated in this initiative and who shared their work with us. For readers whose appetite has been whetted, may the participants' appearance in *In a Whole New Way* serve as a jumping-off point for them to tell other stories on their own.

Most of all, we thank our families—Atefeh Riazi (who made *Project Lives* happen at the housing authority by serving as the program's executive champion), Parisa Carrano, and Soraya Carrano on George's side and Suzanne La Plante, Jinya Fisher-LaPlante, and Dakota Fisher-LaPlante, on Jonathan's—who supported us even during our extended absences while engaged in this effort over a five-year period.

BIBLIOGRAPHY

Abadinsky, Howard. *Probation and Parole: Corrections in the Community (Thirteenth Edition)*. New York: Pearson, 2018.

Aebi, Marcelo F., Delgrande, Natalia, and Marguet, Yann. "Have Community Sanctions and Measures Widened the Net of the European Criminal Justice Systems?" Web: *Punishment & Society*, 2015.

Anderson, David G. *Crime & The Politics of Hysteria: How the Willie Horton Story Changed American Justice*. New York: Times Books, 1995.

Ansbro, Maria. "Integrating Attachment Theory into Probation Practice: A Qualitative Study." Web: *The British Journal of Social Work*, February 12, 2018.

Augustus, John. *A Report on the Labors of John Augustus*. Lexington, Kentucky: American Probation and Parole Association, 1984.

Balko, Radley. "Georgia's Privatized Probation and Parole System Isn't Working," *The Washington Post*. Washington D.C. October 5, 2018.

Bayens, Gerald and Smykla, John Ortiz. *Probation, Parole, & Community-Based Corrections*. New York: McGraw Hill, 2013.

Bermúdez, Ana. "Statement to the New York City Council Committee on Criminal Justice." Web: *New York City Department of Probation Report*, March 15, 2018.

Blarr, Megan. "'Behind Closed Doors': A Look at the Lives of Probation Officers in Cayuga County." Web: *Auburnpub.com*. August 19, 2018.

Blauner, Peter. *Slow Motion Riot*. New York: William Morrow and Company, 1991.

Bohlen, Celestine. "Armed, Dangerous Life of a Probation Officer," *The New York Times*. New York. December 30, 1988.

Bonta, James, Rugge, Tanya, Scott, Terri-Lynne, Bourgon, Guy, and Yessine, Annie K. "Exploring the Black Box of Community Supervision." Web: *Journal of Offender Rehabilitation*, 2008.

Brady, John. *Bad Boy: The Life and Politics of Lee Atwater*. Boston: Adison-Wesley, 1996.

Brown, David, Cunneen, Chris, Schwartz, Melanie, Stubbs, Julie, and Young, Courtney. *Justice Reinvestment: Winding Back Imprisonment*. New York: Palgrave Macmillan, 2016.

Constantino, Bobby. "I Got Myself Arrested So I Could Look Inside the Justice System," *The Atlantic*. Washington D.C. December 17, 2013.

Constantino, Bobby. "When New York City Is a Prison," *The Atlantic*. Washington D.C. January 26, 2015.

Cullen, Francis T., Jonson, Cheryl Lero, and Mears, Daniel P. "Reinventing Community Corrections." Web: *University of Chicago Press Journals*, November 9, 2016.

"Do More Good." Web: *New York City Department of Probation Report*, December 2013.

"Evaluation of the Neighborhood Opportunity Network (NeON) Program." Web: *Metis Associates Report*, December 2018.

Fairey, Tiffany. "Whose Pictures Are These? Reframing the Promise of Participatory Photography." Web: *University of London Doctoral Thesis*, 2015.

Fitzgibbon, W., Graebsch, C. and McNeill, F. "Pervasive Punishment: Experiencing Supervision" in Carrabine, E. and Brown, M. (eds.) *The Routledge International Handbook of Visual Criminology*. London: Routledge, 2017.

Foster, Kmele, narrator. "Has Criminal Justice Reform Made Us Less Safe? A Debate." *Honestly*. October 26, 2022, https://open.spotify.com/episode/5Tq LUdy6tyJS2urgFlDOk1.

Galante, Cecilia. *The Odds of You and Me*. New York: William Morrow, 2017.

Graebsch, C. Beobachtet, aber nicht beachtet. Bericht über die Photovoice-Studie SUPERVISIBLE mit Menschen unter strafrechtlicher Aufsicht, in: Forum Strafvollzug, Vol. 2, 2017.

Hardy, Jason. *The Second Chance Club: Hardship and Hope After Prison*. New York: Simon & Schuster, 2020.

Humes, Edward. *No Matter How Loud I Shout: A Year in the Life of Juvenile Court*. New York: Simon & Schuster Paperbacks, 1996.

Jacobson, Michael P., Schiraldi, Vincent, Daly, Reagan, and Hotez, Emily. "Less Is More: How Reducing Probation Populations Can Improve Outcomes." Web: *Harvard Kennedy School Report*. August 28, 2017.

Klingele, Cecelia. *Measuring Change: From Rates of Recidivism to Markers of Desistance*. Web: *University of Wisconsin Law School Report*, March 15, 2018.

LaGratta, Emily (ed.). *To Be Fair: Conversations About Procedural Justice*. New York: Center for Court Innovations, 2017.

McNeill, Fergus. *Pervasive Punishment: Making Sense of Mass Supervision*. Bingley: Emerald Publishing, 2019.

Miner, Roger J. "Retirement Dinner of Chief US Probation Officer Frank T. Waterson." Web: *New York Law School Report*, 1993.

"Offender Supervision in Europe: Seen and Heard," *COST Action IS1106*. Online. 2017.

Phelps, Michelle S. "To Fix the Justice System, Shrink and Reform Community Supervision." Web: *Robina Institute Report*, 2017.

"Relapsing Shouldn't Be a Crime," *The New York Times*. New York. May 30, 2018.

The Pew Charitable Trusts. *Probation and Parole Systems Marked by High Stakes, Missed Opportunities*. Web: September 2018.

Young, Mark Geoffrey. *The Best Ever Book of Probation Officer Jokes*. New York: Dolyttle & Seamore, 2012.

FAIR USE

MULTIMEDIA

City Hall. Directed by Harold Becker, Castle Rock Entertainment, February 16, 1996.

Going Straight: Probation Officer. Directed by Sidney Lotterby, British Broadcasting Company, 1978.

If I Had Wings. Directed by Alan Harmon, Really Real Films, December 2013.

Probation Officer: First Contact. Directed by Hogokansatsukan1, Uploaded to YouTube, September 17, 2012.

The 400 Blows. Directed by Francois Truffaut, Les Films du Carrosse, May 4, 1959.

The Loneliness of the Long-Distance Runner. Directed by Tony Richardson, Woodfall Film Productions, September 21, 1962.

The Man with Two Brains. Directed by Carl Reiner, Warner Brothers, June 3, 1983.

Willie Horton Attack Ad. National Security PAC, 1986.

PHOTO CREDITS

PRUITT-IGOE COMES DOWN: ©St. Louis Post-Dispatch

AMERICAN PROBATION: Mary Finn et al: ©Possibly N.E.A./Catholic Physicians' Guild; Robert Miller et al.: ©Unknown; Elizabeth Smith et al.: ©possibly N.E.A./ACME; Patricia Mann et al.: ©Daily News; Ray Hulbert et al.: ©ACME; Governor Herter et al.: ©Unknown; Helene Lange et al.: ©Milwaukee Journal; Terrorists: ©AP Wirephoto; Sister Rose Paula: ©Ray Lussier; Robert Johnson et al.: ©The Oregonian; Leslie Bass et al.: ©The Plain Dealer; Jeff Bland et al.: ©Milwaukee Journal; Cayuga County: ©The Citizen

THE ROAD TO REFORM: Meek Mill: ©NBC News; Julie Eldred: ©Jesse Costa/WBUR

REFRAMED: Gallery Presents: ©NY1; Probation Office a Place of Joy: ©The Philadelphia Inquirer; Giving Their Clients an Opportunity: ©WABC-TV

SYNCHRONICITY

©Photos by Supervisible/www.offendersupervision.eu/supervisible/

iSTOCK

Taping dog: iStock.com/gorodenkoff; iStock.com/WilleeCole (dog)

Idaho Falls: iStock.com/SensorSpot

East Boston: iStock.com/Sensor Spot

Chiropractor: iStock.com/MichaelJay

Maine Senior: iStock.com/SensorSpot; iStock.com/SLRadcliffe (catheter)

Biting bro: iStock.com/RichLegg

CPSIA information can be obtained
at www.ICGtesting.com
Printed in the USA
JSHW012245060423
39887JS00001B/1